W9-APS-076

The Art
of Color
Calligraphy

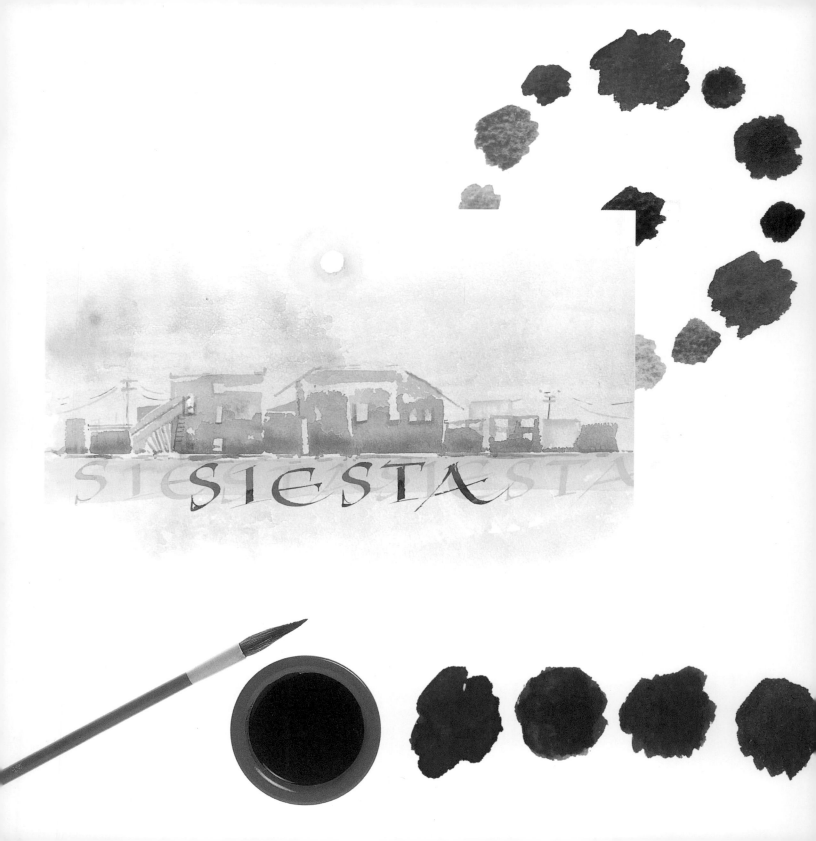

The Art of Color Calligraphy

Mary Noble and Adrian Waddington

RUNNING PRESS
PHILADELPHIA · LONDON

CONTENTS

A QUARTO BOOK

Copyright © 1997 Quarto Inc
All rights reserved under the Pan American
and International Copyright Conventions
Printed by Leefung-Asco Printers Ltd, China
First published in the United States of America
in 1997 by Running Press Book Publishers

This book may not be reproduced in whole or
in part, in any form or by any means, electronic
or mechanical, including photocopying,
recording, or by any information, storage and
retrieval system now known or hereafter
invented, without written permission from the
publisher and copyright holders.

9 8 7 6 5 4 3 2 1
Digit on the right indicates the number of
this printing

Library of Congress Cataloging-in-Publication
Number 96-069261

ISBN 0-76240-000-5

This book was designed and produced by
Quarto Publishing plc
The Old Brewery
6 Blundell Street
London N7 9BH

Senior editor Michelle Pickering
Senior art editor Elizabeth Healey
Editors Mary Senechal, Diana Craig
Designer Julie Francis
Calligraphers Janet Mehigan, Annie Moring,
Mary Noble, Adrian Waddington
Illustrator Mary Noble
Photographers Chas Wilder, Colin Bowling,
Laura Wickenden, Paul Forrester
Editorial assistant Judith Evans
Picture researcher Susannah Jayes
Picture manager Giulia Hetherington
Editorial director Mark Dartford
Art director Moira Clinch
Assistant art director Penny Cobb

Typeset by Central Southern Typesetters,
Eastbourne UK
Manufactured by Regent Publishing Services
Ltd, Hong Kong

This book may be ordered by mail from the
publisher. Please add $2.50 for postage and
handling. *But try your bookstore first!*
Running Press Book Publishers
125 South Twenty-second Street
Philadelphia, Pennsylvania 19103-4399

COMBINED

BORDERS AND IMAGES

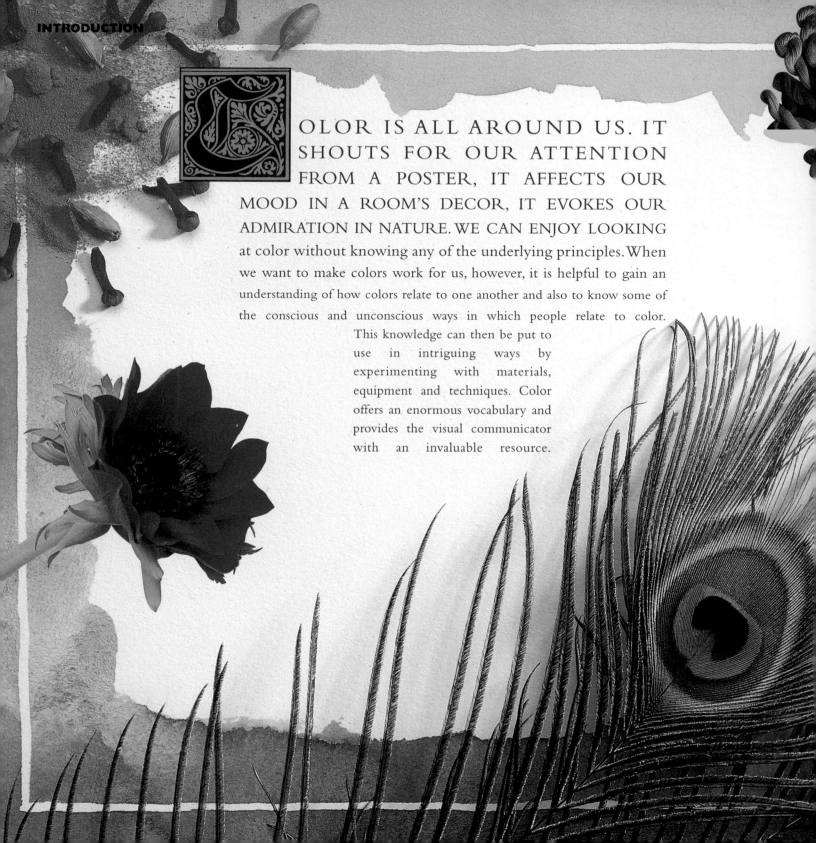

COLOR IS ALL AROUND US. IT SHOUTS FOR OUR ATTENTION FROM A POSTER, IT AFFECTS OUR MOOD IN A ROOM'S DECOR, IT EVOKES OUR ADMIRATION IN NATURE. WE CAN ENJOY LOOKING at color without knowing any of the underlying principles. When we want to make colors work for us, however, it is helpful to gain an understanding of how colors relate to one another and also to know some of the conscious and unconscious ways in which people relate to color. This knowledge can then be put to use in intriguing ways by experimenting with materials, equipment and techniques. Color offers an enormous vocabulary and provides the visual communicator with an invaluable resource.

Several calligraphers contributed to this book. When you put calligraphers together and set them off to explore the possibilities of certain techniques, sparks of inspiration start to fly. The resulting wealth of ideas is here for the reader to dip into and explore. What we learned, and hope to help you discover, too, is that if a piece does not turn out the way you expected, then you have made another discovery. Note down what you did and what resulted, see if you can decide *why* it happened, and ask yourself how this unexpected outcome can be put to advantage in some other way.

For example, you try rollering a color but it goes on unevenly because there is something on the table underneath which has made a ridge in the paper surface. Abandon the original aim, and try putting different objects underneath to work out ways of capitalizing on this happy accident. Thus are new discoveries made.

Most of us started our calligraphic experience with black ink on white paper. First steps into color can be exciting, but for some this stage proves frustrating. Now we discover that mixing colors does not always result in what was expected; that we need to know about opacity and transparency; that some inks are waterproof and some are not.

This book is dedicated to all those who have gained a good, solid grounding in their calligraphy, but who have then dipped a toe in the colored water only to find it too hot. Our aim is to explain about the materials, show how to mix colors to get what you want, demonstrate some techniques for using color in imaginative ways, and encourage you to progress from these starting points to your own discoveries.

In the final section, you will see a gallery of work by contemporary calligraphers, many of whom are pushing out the boundaries of preconception of what can be done with calligraphy, and using color and design to interpret the chosen words in creative and lively ways. Notice, when looking at these pieces, that while the work is colorful and the layout unusual, the skill in writing and the sense of space and balance is evident.

Above all, enjoy this book for the adventures it describes; try them for yourself and adapt them to your own needs. Have lots of fun!

THERE ARE MANY POSSIBLE INKS, PAPERS AND PENS TO TRY IN YOUR SEARCH FOR COLORFUL CALLIGRAPHY. START BY INVESTIGATING WHAT YOUR NEAREST supplier of artists' materials can provide, and experiment; and try some items that are not labeled as suitable for calligraphy. Then move farther afield, and get advice from other calligraphers for places to go. Remember to look on every experiment, successful or not, as a useful learning experience.

The materials used throughout the demonstrations in this book include a wide range of paints, inks and chalks, as well as masking fluid, bleach and a variety of gold and silver media. Each is used on a number of drawing surfaces and applied with various different implements.

There are many formulations now of paints and inks designed for specialist use. Paints and inks are made from pigments or dyes. Pigments are finely powdered, insoluble materials, chosen for their color properties, from plant, animal or mineral sources. These insoluble materials are mixed with a fluid to make the paint flow and a glue to make it adhere to surfaces. Some fluids and glues are oil-based, some water-based, and some acrylic, hence the variety of inks and paints available. Dyes are more of a stain, and have no substance; they are soluble and, as above, are mixed with a fluid and glue.

Paints and inks made from dyes are generally transparent because they have no particles to block out the light. Inks intended for fountain pens are made from dyes, as most pigments would clog the sophisticated "controlled leak" design of ink feed. Some inks and paints are made from a combination of dyes and pigments to gain the greatest benefit from their collective properties. To find out how transparent or opaque an ink or paint is, do some trials across several colors of paper and note how they vary in intensity and brilliance from a trial version carried out on white paper.

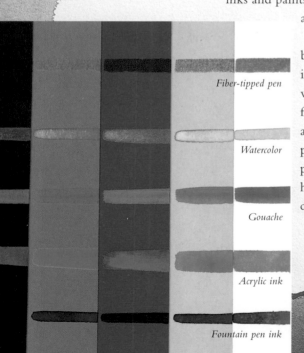

Fiber-tipped pen

Watercolor

Gouache

Acrylic ink

Fountain pen ink

WATERCOLORS

These come in tubes and in pans. Watercolor paints are bright and mainly transparent; they therefore work best on white paper which enhances their colors. Artists'-quality watercolors are made from the best pigments, and they have the most reliable lightfast properties. Student-quality watercolors are made from cheaper ingredients and give poorer results. Watercolors are very good for color washes and take overlap well due to their transparent nature.

POSTER PAINTS

These are cheap paints made for children. Brightness and quantity are their chief qualities. They are ideal for fun projects or experiments in large temporary work. They are generally too coarse for use in the pen, but black poster paint is ideal for use in homemade pens such as those used on page 36. The colors will fade after long exposure to light.

GOUACHE

Available in tubes, the color range of gouache is similar to that of watercolors – vast! – but they differ from watercolor in being opaque and therefore suitable for use on colored backgrounds. Good-quality gouache paints work well in the pen, giving strong color coverage. They are also good for color washes, but beware of trying to write on top as the wash will tend to make the lettering bleed. Spray with fixative or dust with powdered gum sandarac.

WATERPROOF INKS

Inks such as acrylic inks are water-soluble when applied, and waterproof once dry. Other inks contain shellac to make them water-resistant when dry. In either case, take care when using them with brushes and other equipment,

and make sure you wash them out completely before the ink dries on them; acrylics are particularly difficult to remove from dishes if left to evaporate.

All these inks are semi-transparent, so you can build up layers of thin ink to create backgrounds; these will resist "feathering" when you write your calligraphy on top.

Acrylic inks are formulated for the pen and are more manageable than writing with acrylic paints. Use them for large writing; their consistency does not allow for detail and hairlines which are a feature of small-scale work.

OIL-BASED INKS AND PAINTS

Oil-based media are difficult to use in a pen but can make exciting backgrounds, rollered, scraped or brushed across the surface. Building up a background with overlays is easy to do, just as with acrylics. The paint takes time to dry, so use this to your advantage and stir in other colors, mixing them on the page and spreading with a roller or piece of cardboard – now try scratching patterns across the surface. You can then write on top with gouache without the problem of spreading paint. Test the color first, though, as the oil will stain some papers.

CHALKS

There are many types of chalk, some oil-based, some not. The non-oil-based ones are ideal for scraping onto the paper and rubbing in for overall color effects. If you do not like the effect, you can remove chalk with an eraser.

avoid clogging and stringiness. Brushes should be washed out immediately in cold water or they will be ruined. When the masking fluid is dry, apply the colors you want over the surface of the dried fluid. When the colors are dry, rub off the rubbery masking fluid to reveal the previous surface.

GOLD AND SILVER MEDIA

Artificial gold and silver are available in inks and paints which are suitable for use with brush or pen. They are all made from finely ground, non-soluble materials, usually metals, which are heavy and tend to separate. Frequent stirring is necessary.

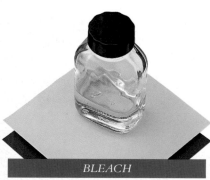

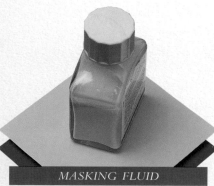

MASKING FLUID

This is a very useful material for covering areas which you want to remain free of paint. The fluid smells of ammonia and dries quickly on exposure to air, so it is necessary to work fast. It is best to decant a little into a dish; if it thickens, add a little water.

Masking fluid can be applied with a brush or a pen, but take care to wipe the pen frequently to

BLEACH

Take care when using bleach as spills on clothes will cause irrevocable damage. The demonstrations in this book use a solution of about 1 part household bleach diluted with 4 parts water. It is best to mix the bleach solution and keep it in a small, screw-topped jar – and label it clearly if not discarding it after use.

Trials with the inks you are using will tell you if the strength is right: too strong and the bleach will bleed too much into the ink, creating fuzzy edges and even rotting the paper; too weak and it will leave the ink unaffected.

REAL GOLD

There are three forms of real gold available. "Shell gold" is the finely ground version. It comes in a small cake and is used in the same way as watercolors. Gold leaf is sold in books of 25 sheets and comes either attached to its backing paper — "transfer gold" — or as "looseleaf gold." This last comes in single or double thicknesses. Gold leaf needs a glue base to attach it to the paper. Traditionally this is gesso but a gum base is a cheaper alternative.

PENS

Any implement which can make a mark might legitimately be called a pen. In this book several ideas for making your own are given, as well as suggestions for unconventional uses of traditional tools such as the ruling pen, which is now frequently employed as a freehand writing implement.

The principal writing tools, however, are metal dip pens of all sizes, including large poster pens such as "automatic" pens. Fountain pens are of limited use in color calligraphy because they require much washing out to change colors, and using paints and acrylic inks would clog and damage them.

Fiber-tipped pens are convenient and fun, and ideal for quick ideas. As with homemade pens, fiber-tips will eventually lose their sharpness. The inks in fiber-tipped pens are not lightfast so are best used for design ideas and for projects of short-term use, such as addressing envelopes.

PAPERS

Papers come in different surfaces, thicknesses and colors. Most of the demonstrations in this book have used thick paper or card because of the overall washes and other treatments which cause cockling in thin paper (alternatively the paper has been stretched: see page 50).

The thickness of paper is expressed either in imperial weight, or in grams per square meter. The following table may be of help:

48lb	=	**100gsm**
72lb	=	**150gsm**
90lb	=	**190gsm**
140lb	=	**300gsm**
300lb	=	**638gsm**

To give you can idea of thickness, 100gsm is the thickness of good-quality, letter-writing paper, while 300gsm paper is the weight you might find in the watercolor pads most commonly used by artists.

Machine-made papers come in three kinds of surfaces — *Hot Pressed, Cold Pressed* (also known as *Not* paper) and *Rough*. Hot Pressed means that the paper has been passed through hot rollers resulting in the smoothest surface, which makes it popular with calligraphers. Cold Pressed, or Not, means that the paper has been passed through cold rollers so its surface is a little textured; this surface is commonly used by watercolorists. Rough means that the paper has not been passed through rollers at all and therefore has a very textured surface.

Handmade papers vary in their surfaces, and are worth exploring in their own right. They will cost more per sheet to buy than machine-made papers but have more character. If you cannot bear to mark them with ink or paint, consider using them as endpapers or covers in handmade books.

Mountboard and various cards are used in some of the techniques. Mountboards come in a wide selection of colors; some are bright, most are subdued as their primary function is for framing. This surface is worth exploring for color work as the board is thick and will therefore resist curling.

THE
PRINCIPLES
OF
COLOR

IGHT IS NECESSARY IN ORDER TO SEE COLOR. SIR ISAAC NEWTON (1642–1727) DISCOVERED THAT BY HOLDING A GLASS PRISM IN A BEAM OF SUNLIGHT HE COULD reproduce what nature does with water droplets – split light into all the colors we see in a rainbow. We refer to these as the colors of the spectrum. What Newton had in effect done was to identify lightwaves from ultraviolet to infrared, which we cannot usually see.

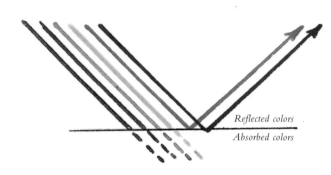

Reflected colors
Absorbed colors

LIGHTWAVES

Lightwaves become visible when they strike a surface; depending on what molecular properties that surface has, the spectrum of lightwaves will be absorbed or reflected by different amounts. What our eyes pick up as "color" is the rejected portion of the lightwaves. Thus, a surface which reflects all the color waves completely will appear white to the eyes, because the light is unchanged. The surface of a scarlet rose will absorb nearly all the colors but reflect red, and a small proportion of orange. A surface which absorbs the whole spectrum will leave nothing to reflect back to our eyes, so we will perceive black.

COLOR THEORY

Paints and inks are made from pigments or dyes, raw materials which have been picked for their properties of reflecting certain colors. To attempt to make all the colors of the spectrum with pigment, we need to start with a minimum of red, yellow and blue. These are known as primary colors because they are the starting point, and from these we can mix all the others. The primary colors red and yellow make the secondary color orange; primary yellow and blue make secondary green; primary blue and red make secondary violet – in theory, that is.

Anyone who has mixed a blue and a red and tried to get a violet will find that sometimes the result is brown instead. That will be because the red they chose was biased toward orange (had a hint of yellow in it), or the blue they used was a bit biased toward green (had a hint of yellow in it) – or both! Thus what has been mixed is red, blue and some uninvited yellow, which has produced a subtle brown instead of the intended bright violet.

The color wheel below is somewhat misleading as it is an idealization of the spectrum. In other words, the red that was used to make the violet is not the same red that made the orange, because pigments are not that conveniently adaptable – and the "fake" primary red is actually a mixture of the

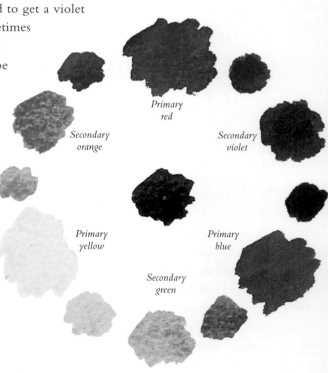

Primary red

Secondary orange

Secondary violet

Primary yellow

Primary blue

Secondary green

two. The same applies to the blue and yellow. We need to know which way a color is biased so that we can mix the colors we really want. So, to obtain that elusive bright violet, the best result will be obtained from using a red with a blue bias and a blue with a red bias. The color wheel on the right is more helpful because it shows the bias of different colors.

When faced with the bewildering array of colors available in the shops, the safest course is to collect six primaries – two reds, two yellows, and two blues – each with its bias known to us, so that uninvited colors do not creep into the mixture. In watercolor or gouache paints, the following list is one suggestion:

Alizarin Crimson
French Ultramarine
Cerulean Blue
Lemon Yellow
Cadmium Yellow
Cadmium Red

Mixing Cadmium Red with Cadmium Yellow should result in a bright orange, because no blue bias has been incorporated. If, however, a browner orange is required, change one or both of the primary colors to versions with a blue bias:

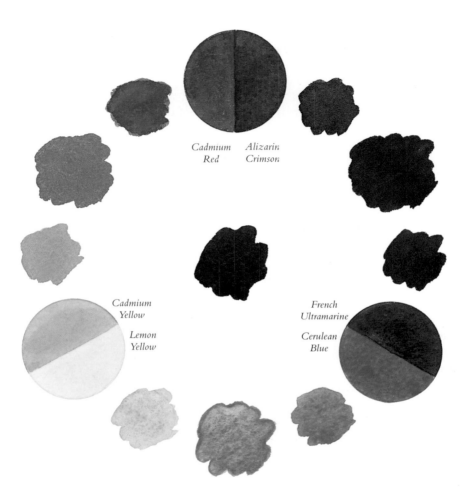

*Cadmium
Red* *Alizarin
Crimson*

*Cadmium
Yellow*

*Lemon
Yellow*

*French
Ultramarine*

*Cerulean
Blue*

for example, substitute bluish Alizarin Crimson for the orange-biased Cadmium Red.

Equal intensities of two primaries will theoretically produce a clear secondary color, provided the bias is right; Cerulean Blue with Lemon Yellow should give a bright green that is midway between yellow and blue, that is

neither a blue-green nor a yellow-green. Tertiary colors – the product of one primary and one secondary – are the ones that make blue-greens, yellow-greens, etc. All these colors are sometimes referred to as *hues*, that is, they are just themselves with no white or black added to them, and are clear, bright colors.

15

MIXING COLORS

Recalling the earlier discussion on lightwaves being absorbed and reflected, consider what happens when all three primary colors are mixed together. When a color is reflected to our eyes, all the other colors of the spectrum we are not seeing are being absorbed. Therefore, if all three primaries are mixed together in equal intensities, the compound absorption should result in something very near to black. The color in the center of both circles on the previous pages is a mixture of all the colors. If the balance of intensities is uneven, the result will still be interesting, making many variations on brown.

Experiment with any three primaries and see what results. Remember that the effects will differ depending on the bias of your chosen colors – change your red to a different bias, for example, and the resulting brown or gray

will be different. Many versions of brown will have been discovered during trial mixes of this kind, and now that you are familiar with mixing three basic primary colors, you will find that mixing all three at varying relative quantities will provide endless permutations.

TINTS AND SHADES

Adding white to a color, or hue, changes its nature and turns it into a *tint*; for example, add white to red and it turns into pink. White also adds substance to the pigment and makes it more opaque. Another way to add white is by thinning the paint so that the

white of the paper shows through; this latter method is done constantly by watercolorists.

Adding black to a color (hue) turns it into a *shade*. This generally has the effect of dulling the colors and should be used with caution. If the intention is to darken but not kill the color, then it is usually better to mix in a little of its opposite, in preference to using black. Opposites, which are known as complementaries, are discussed on pages 17–19. In the sample shown below, the final mixture is of the tint and the shade combined, which produces a dusty color. Try tints and shades with other hues.

The top row shows various shades of red; the bottom shows varying tints of red. The final color on the right is a mixture of tints and shades.

The color swatches on the left show the results of mixing equal quantities of two primary colors with a greater amount of the remaining primary.

PUTTING COLORS TOGETHER

In calligraphy the relationship between colors can be just as important as the colors themselves. The following explanations illustrate some of the effects that you can achieve.

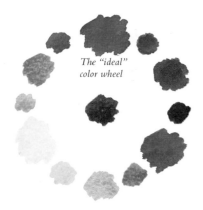

The "ideal" color wheel

Try this exercise. Choose a primary color, and mix next to it several gradations toward one of its two secondary colors (for example, if starting with Cadmium Red, go toward orange; if Cerulean Blue, go toward green). This selection of colors will be subtle, but all very similar. Many projects will call for subtle changes like these, perhaps as backgrounds ready for a contrasting image on top. These are described as *analogous colors.*

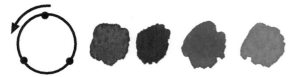

Move one sixth of the way around the color wheel from the primary to the nearest secondary.

Continue with this color range until you have progressed as far as you can around the color circle before hitting the next primary. This selection of colors gives a much wider range — it goes one

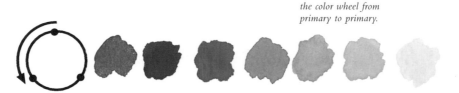

Move one third around the color wheel from primary to primary.

third around the wheel and goes from one primary to another. Later you can try starting from a different point on the circle. Now add to the collection one more set of gradations, to the next secondary, so that you have traveled halfway around the circle. Look at it carefully. You now have, at opposing ends, a primary and its complementary secondary color. The colors gradate harmoniously. They are all bright colors, because they have been used individually, or mixed with a proportion of one other color near to them.

Put the two complementary colors together — red and green, yellow and violet, or blue and orange. Pairs of complementary colors create vibrancy when placed next to each other.

Now we will see what happens if we take a short cut and travel across the middle of the color circle, instead of around the perimeter. Take the colors at each end of your previous experiment, in the example shown, red and green, and through gradual stages, add a very small amount of the other color to each.

Travel around the wheel from the primary to its complementary secondary color.

The colors will become slightly duller, or neutralized. Continue mixing in increasing amounts toward each other; they will go toward browns. When you have mixed equal intensities you will have a neutral gray. You have now traveled across the color range in two ways: around the circle halfway, giving bright colors throughout; and across the middle, resulting in browns to grays.

Color theorist Johannes Itten believes that the eye searches constantly for equilibrium. Try staring at bright red for a few moments and when you look away you will see its opposite, green. This is the eye, or brain, taking compensating action. His theory is that all colors of the spectrum need to be represented in balance in order for the eye to perceive harmony. Thus, a painting that confines its color range to all the oranges (such as our first test piece) will not be harmonious to the eye until it can be balanced with some of the remaining spectrum – so in this case it would need blue. To check that they are complementary, mix them to see if they make neutral gray.

Thus, without using black, it is possible to create a dark gray which is very near to black. Many artists eschew the use of black paint as it deadens colors; they can use complementaries to get the effect of shadows, achieving a more harmonious and natural look. They know what Itten proved with light. He conducted an experiment shining a red light on a white object; it cast a green shadow. Yellow light cast a violet shadow, and blue light cast orange. He proved it was not an optical illusion as he was able to photograph the results.

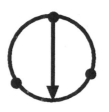

Experiment moving across the middle of the color wheel rather than around it; the result will be neutral grays.

COLOR EFFECTS

Consider colors in nature, for example, a cluster of red and green in equal amounts such as you might see when the leaves are turning at the end of the season. These are complementaries creating vibrancy. Now look closely at one leaf, and notice how the colors blend from red to green, going through the neutral browns to grays, in just the same way as would be obtained from mixing paints. They may not be so vibrant with the intermediary colors, but there is a multitude of attractive color combinations.

Nature also knows how to gain attention by using colors sparingly – a few dots of tiny red flowers against a backdrop of green leaves guarantees their being noticed. In addition to these complementary and proportional contrasts, there are other ways too; light against dark, bright against neutral, cold against warm colors. A great deal can be learned by observing the colors you see around you.

Use a sketchbook to record color schemes that you like, whether the source is a restaurant interior, an advertisement poster or a natural landscape. Try to observe colors more closely and the ways in which they are deployed. This will help you to build up a good sense of color.

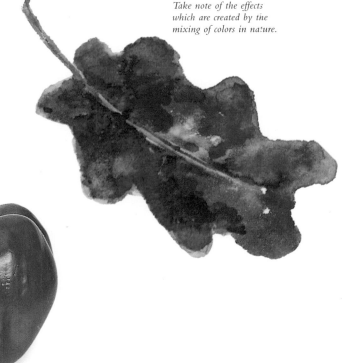

Take note of the effects which are created by the mixing of colors in nature.

COLOR HARMONY

Colors are seldom viewed in isolation. For example, a massive amount of orange ceases to be stimulating; we need contrast and variety in color. Since we are in contact with more than one color at a time, color harmony is an important factor in our sensations. Colors that may be attractive separately can be unpleasant when placed side by side.

SINGLE–HUE HARMONY

Nature provides many examples of single-hue harmony, such as in the shades of green foliage or the various tones found in the sea. In calligraphic terms, such a scheme might suit a subtle background, and would need contrast in the main focal point.

ANALOGOUS COLOR HARMONY

Two close colors, such as green and yellow-green, share a common denominator, in this case yellow; they are an example of analogous harmony. They have a similarly subtle effect to single-hue ranges, but are a little brighter if no tint or shade is included.

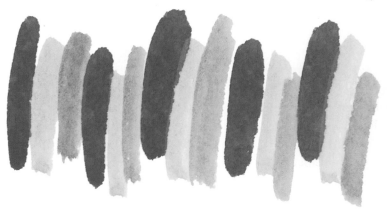

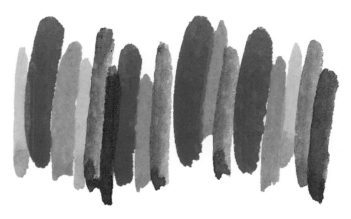

Analogous colors (above) have the same subtle and harmonious effect as that of single hues (left).

HARMONY OF CONTRAST

Introducing a small amount of a complementary to analogous colors can provide sparkle.

Use complementary colors to highlight details.

COMPLEX HARMONY

Johannes Itten maintains that true harmony occurs when there is order and balance in the choice of color. True balance can be tested by mixing the chosen colors together to see if the result is gray (demonstrating equilibrium, as described on page 18). In other words, if in some way all three primaries have been incorporated. This may sound more like chaos than harmony, but give it a try.

If colors are chosen from across the color range, as Itten recommends, such as from equal distances around the color circle, this will give us complex and vivid combinations, but care will have to be taken to get the balance right.

For example, red, blue and yellow – the primaries – mixed together will result in neutral gray (we are ignoring biases here). They will provide bright color schemes. The three secondary colors will produce a bright though more muted scheme than the primaries. Now if we take red, and find two other colors which between them incorporate a balanced amount of the yellow and blue – blue-green and yellow-green – these will again make a vivid color combination.

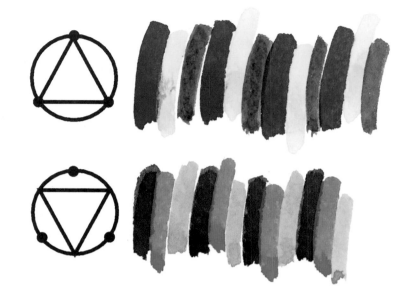

Note the different effects created by the triangular color scheme of primaries (top) and of secondaries (above). Then experiment with more complex schemes such as a primary with its two opposite tertiaries (below) or a four-color collection from equidistant points on the color wheel (bottom).

To achieve greatest brightness in a four-color collection, choose four colors in the circle that are the same distance from each other, or in other words, two opposites and two at right angles to them. For example, if we start with red again, we get green opposite, and then at right angles to this are yellow-orange and blue-violet.

These complex color combinations will, at their best, provide exciting visual effects; used inappropriately, however, they could confuse a design rather than enhance it. Bear in mind the effect you want to achieve, and decide what you want to be dominant. The complex combinations are designed to be equally bright, which may not suit your intention. You may need some contrast.

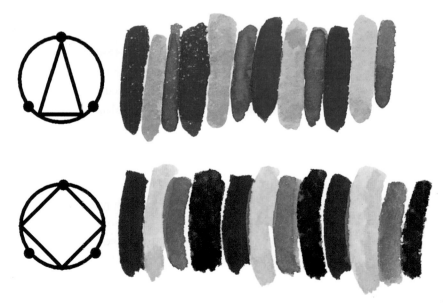

CONTRAST

There are many ways to achieve contrast; you can highlight a small area, or create a flashing, uncomfortable effect to the eye, or use a gentle contrast to focus attention on the main part of your piece of work.

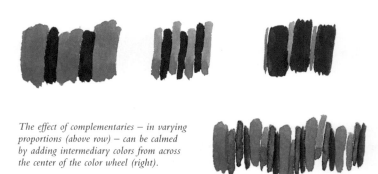

The effect of complementaries – in varying proportions (above row) – can be calmed by adding intermediary colors from across the center of the color wheel (right).

PROPORTIONAL CONTRAST

The relative areas of the colors used is a constant factor to bear in mind with all the other considerations. We have already discussed the vibrant effect of complementary colors: much depends on the proportions in which they are used together. Small pockets of one color will catch the eye against a mass of its complementary. Equal amounts of both colors will make striking effects as the eye moves rapidly from one to the other – for example, stripes can be difficult to look at as the eye searches for the dominant area on which to rest. More colors in the design will complicate the effect or add to its vibrancy, depending how well they are related.

Using colors from opposing sides of the circle provides ready contrast. It is the most vivid form. How much of each color, and whether you calm the effect by adding intermediary colors, will affect the degree of impact.

LIGHT–DARK CONTRAST

Contrast can even be achieved using a closely related color range (close on the color circle) by setting different tones against each other – such as pink against dark brown. Again, the proportions will also determine the amount of contrast achieved.

Placing pink against dark brown (left) utilizes the tonal differences of two colors that are close on the color wheel to create contrast. Colors such as yellow and blue (above) have inherent tonal contrast.

Light-dark differences also occur with the inherent tonal differences between colors. Lemon yellow, for example, has the lightest tone of all the colors in the circle, and the blues and violets have the darkest. These tonal differences need to be borne in mind when balancing a composition, and colors altered in tone to compensate if you are getting more contrast than you intended.

COLD–WARM CONTRAST

Reds are seen as warm colors, blues as cold. Thus a visual temperature or contrast with different temperatures can be effective. It is all relative, however; put a violet in with a range of cool blues or neutrals, and it will appear warm. Put the same violet with warm reds and grays, and it will seem cool.

Violet can appear either warm or cold depending on the colors it is near.

CONTRAST OF INTENSITY

This is different from contrast in tone, although tonal values may come into play. Here we are talking about the strength and purity of color. A clear red will stand out against a brown-red and a brown-green, because it is brighter. This is because it has not been mixed with other hues, as have its accompanying colors.

Note how the red stands out.

SPACIAL EFFECTS

In compositions using several colors, some colors appear to advance and others recede. In multicolored examples, yellow will generally appear to be nearer than blue or violet because of their difference in reflectance values (violet absorbs more light than yellow). Similarly, warm colors often appear closer than cold, again partly because of their relative absorption but also because of our experiences – we know that the air makes distant hills look cool gray-blue, for example.

BLACK AND WHITE

Black and white on a colored background advance and recede more than colors do. Because white has maximum reflection, it appears to jump out as the light spills from around it. Meanwhile black sinks into the background because it absorbs all the light. This is an optical illusion which is a useful tool for calligraphers, as a block of text in white against blue will appear larger than the same text in black.

Black recedes and white comes forward to create a useful optical illusion.

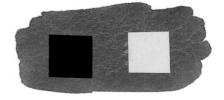

Note how red and yellow come forward and blue recedes.

COLOR PERCEPTIONS & PREFERENCES

The perception of color is the strongest part of the visual process and can therefore be used to our advantage in expressing and reinforcing visual information. Color contains universal meaning in some contexts, while each of us also has individual color preferences and views.

Our color preferences are conditioned by various factors – the specific value of the hue, the area the color occupies, the presence of other colors, and the object with which the color is associated. These preferences are subjective: they are part of our character and are usually ingrained in the unconscious mind. Color acts on emotion, not on reason, and so provokes spontaneous and sometimes surprising responses.

According to color theorist Louis Cheskin, "color preference tests have demonstrated that reds, violets, and blues (half of the color circle) are liked much more than oranges, yellows, and greens. Among men blue is first, and red is the favorite of women."

To take one example, orange-red is vibrant, sharp, and stimulating, so much so that many people do not like it. However, when diluted with white to form peach, it is highly popular.

Pure colors are generally preferred only in small areas, when they are not over-stimulating. A color may also be liked on a wall, but disliked in clothing, and vice versa. Strong and pure colors are best at grabbing attention, but subtle tints are much more successful in holding it.

We need to be aware of our color environment and conscious of reactions to the specific colors that produce sensations of warmth or coolness, stimulation or relaxation, cheer or gloom, pleasantness or discomfort. Although red, violet, and blue are judged more pleasing than other colors, for example, most people react more favorably to green-blue than they do to violet-blue. The psychological response to yellow is less positive than to red or blue, and the slightest change in yellow renders it either cold or warm, soothing or irritating. Yellow therefore needs careful handling. We are constantly surrounded by green, and because it is unconsciously associated with food, nature, and growth it produces the calmest reactions.

COLOR SYMBOLISM

Time and tradition have created strong, symbolic color connections. For example, we associate red with festivity, blue with distinction, purple with dignity, green with nature, yellow with sunshine, pink with health, and white with purity. Context also gives color specific meaning – we know that red means stop, and green means go.

Colors are also linked with the expression of emotions and attitudes. Red is associated with love or hatred, blue with despair (the "blues"), yellow with cowardice (that "yellow streak"), green with jealousy (the "green eye"), and white with peace.

Just as painters utilize the associations of colors, so can the calligrapher. The following descriptions, based on some of the more common color connections, can help you to emphasize meanings and improve your interpretation of pieces of text.

RED Red is a strong color that advances from a surface, and is thought to be arousing. Symbolically red is associated with fire, love, joy, passion, and energy. As an heraldic color, red embodies courage and zeal. It is also connected with revolution, blood and anger.

YELLOW There are many shades and tones of yellow and gold, providing numerous associations, notably with objects and effects found in nature, including light, the sun, and flowers. The heraldic use of yellow to indicate honor and loyalty is contradicted by later connections with cowardice. The brightest color in the spectrum, yellow is seen before other colors when placed against black. This combination is often used as a warning sign – in nature, by insects such as bees, and to signal hazards in industrial situations.

GREEN Green symbolizes nature, freshness, growth, and fertility, as signified by plants, seedlings, grass, and vegetables. In heraldry, green indicates growth and hope. Green is also associated with naivety and jealousy. It conveys a sense of restfulness and adds balance to interiors.

BLUE Blue's strongest association is with the sky and the sea. Although a cold and retractive color, blue is said to have a pacifying influence. Blue also symbolizes peace, faith, contemplation, truth, and heaven. In heraldry, blue is used to indicate piety and sincerity.

VIOLET Violets and purples are rich colors and often convey wealth, extravagance, and preciousness. In heraldry, purple depicts royalty. Other connections include knowledge, old age, magic, and enchantment.

ORANGE Orange is present in nature, in the setting sun, fall leaves, fruit, and flowers. Orange stands out well and creates a sense of warmth. In heraldry, orange is a sign of strength and endurance.

BLACK Black often symbolizes death, darkness, and evil. In nature, however, pure black is rare. Many insects appear black, but in fact contain numerous colors. Black is found in minerals and ores. In heraldry, it is the symbol of grief.

WHITE White is sometimes described as an absence of color, although it does appear in different shades – for example, with a faint yellow or blue tinge. It is most strongly linked with light, which allows us to see all of the other colors. White symbolizes innocence and in heraldry depicts faith and purity.

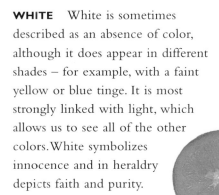

ALPHABETS

LPHABETS CAN BE ARRANGED IN AN INFINITE VARIETY OF LAYOUTS WITHOUT PREJUDICE TO THE MEANING, MAKING THEM A VERY USEFUL BASIS FOR A DESIGN. THEY ARE used here to illustrate how simple and complex use of color in the letters alone can be sufficient to make an eye-catching piece of work. Single letters can have the same treatment, and clearly this principle can be developed for words, quotations and longer pieces of text.

MATERIALS

Ink

Metal pen

Layout paper

Pencil or fiber-tip pen

Scissors

Watercolors

Gouache

Thick colored paper

Ruler

Eraser

Automatic pen

A STRIKING PIECE OF WORK CAN BE ACHIEVED FROM A LIMITED COLOR PALETTE. THIS SIMPLE ONE-COLOR ALPHABET IS ENHANCED BY CAREFUL CHOICE of background texture and color. Here, the rough texture of the paper leaves small gaps and irregular shapes within the pen strokes, resulting in a feeling of swiftness and lightness within the letters.

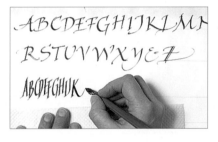

1 Using ink and a metal pen on layout paper, practice drawing different suitable letterforms.

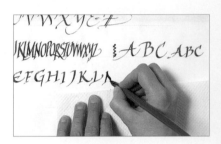

2 For this alphabet, condensed and expanded letters, and differing cap heights are drawn before a final choice is made.

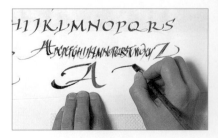

3 Combining different-sized letters often creates balance or emphasis. Here, larger letters are used for the *A* and *Z* to form a neat beginning and end.

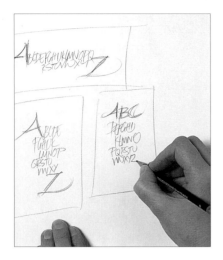

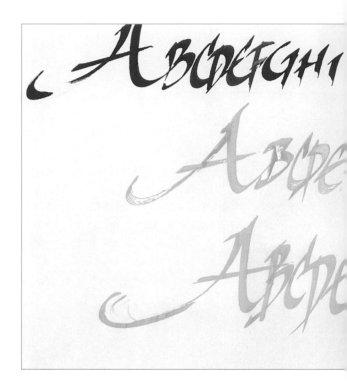

4 After deciding which letters to use, the overall composition of the alphabet must be determined. Sketch this out roughly first, using a pencil or fiber-tip pen on layout paper.

6 As well as choosing the color for the letters, you must also pick the medium. The best way to decide is by drawing the letters in different colors of ink, watercolor, and gouache; and then compare them.

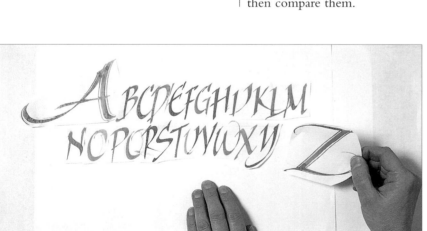

5 Draw the letters out, real size, in ink on layout paper, and cut them out. You can then move the pieces around until you are satisfied with the composition.

7 It is important to try the colors and mediums on a sample of your intended background. In this way, you can be sure of how the letters will look and read on differently colored surfaces. Gouache is opaque, and when mixed correctly will provide a strong color, without the background showing through. Watercolors and some inks will be affected by the background color.

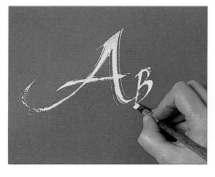

8 The experiments show that yellow gouache on the green background provides an effective solution, allowing the letters good prominence and legibility. Rule faint guidelines with a pencil before drawing the letters. The lines can be carefully removed with an eraser when the gouache is dry.

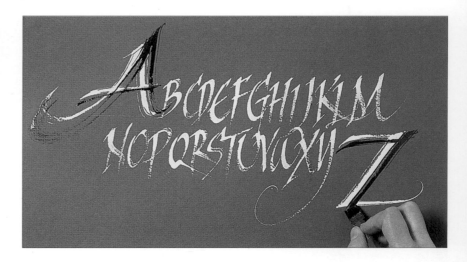

10 To add a little more emphasis to the *A* and *Z*, and to assist visually in holding the alphabet together, a dark blue is introduced after the yellow has dried. Redraw the *A* and the *Z* with blue, slightly offset from the yellow. This shadowing effect gives the *A* and the *Z* depth, so that they appear to stand out from the other letters.

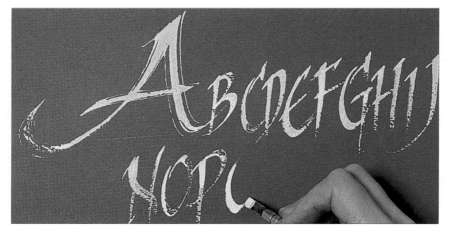

9 Continue to draw the alphabet, refilling the automatic pen after each letter. This ensures consistent color density in all of the letters.

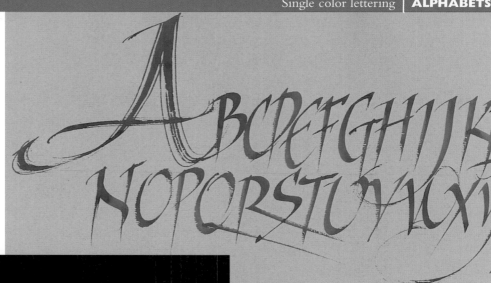

Green on green

This monochromatic color scheme is a good example of single-hue harmony. The darker lettering stands out against the lighter background.

Red on black

Red is the warmest and therefore most advancing color on the color wheel. It is particularly effective here against the strong matt black background.

Blue on orange

The use of primary blue and secondary orange produces stunning results. Such a combination utilizes the attraction of color opposites.

MATERIALS

Watercolors or inks
Paintbrush
Drawing paper
Water
Automatic pen
Paper towel
Rough watercolor paper

WE USUALLY WRITE CALLIGRAPHY BY LOADING THE PEN WITH A SINGLE COLOR, OR SOMETIMES BY CHANGING COLORS WITHIN THE PIECE OF WORK.

Here, we write instead with clear water, and then add colors. Any water-based medium can be used but fatter letterforms are best. The results are never predictable, but always exciting!

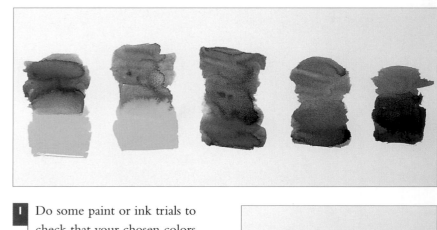

I Do some paint or ink trials to check that your chosen colors blend well. Limit the colors to two or three, because every addition increases the potential for muddying the mixture.

2 Place the paper on a flat surface, and write the letter with clear water and a clean, wide pen. It should look wet all over, but without puddles – soak up any excess with paper towel.

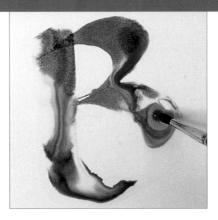

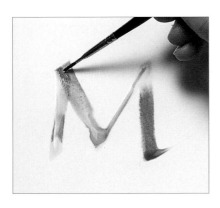

3 Load a paintbrush with the first color and touch it into the watered letter in several places; it should flood in.

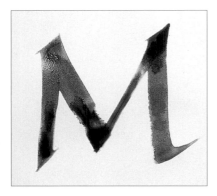

4 Do the same with a second color, and watch how it runs and mixes with the first; there should be no need to move the paper around to help the blending. Speed is important, to add the colors before the water evaporates, but you can touch in more water if you are careful.

5 Try writing a fatter letter; this will give a bigger surface area to flood color into.

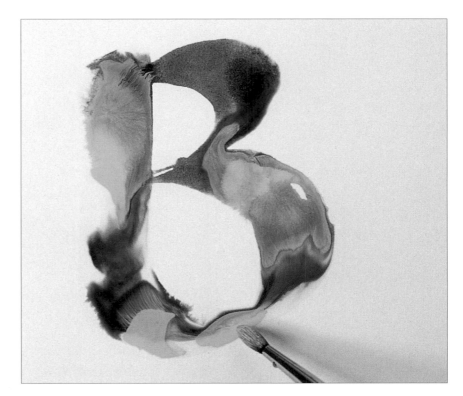

6 In this example there is room to add a third color. Choose it carefully to merge well with both of the others.

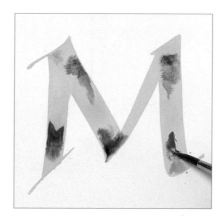

8 Then add a second color, allowing it to flow in. Here, blue blends with the yellow to make patches of green.

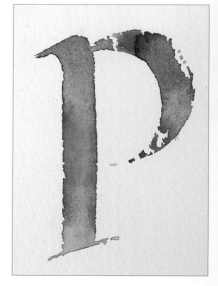

10 This letter shows quite a lot of merging, but the colors remain bright. The areas where the paper remains uncolored act as effective highlights.

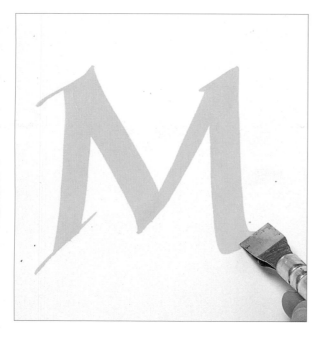

7 A more controllable variation is to write the letter with a pale color – yellow works well – keeping it wet.

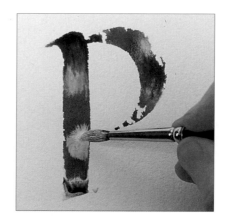

9 Textured paper, such as rough watercolor paper, gives an interesting pitted effect. Follow the same procedures, but when touching in the colors, watch for areas where the color will not run because of the pits.

Controlled blending

This controlled blend of colors is achieved by writing the letters in watery magenta first and then dropping the second color into it.

Random blending

This gothic T is created by using watery blue on yellow paper. Yellow and gold paint are then dropped in to introduce the random patterning.

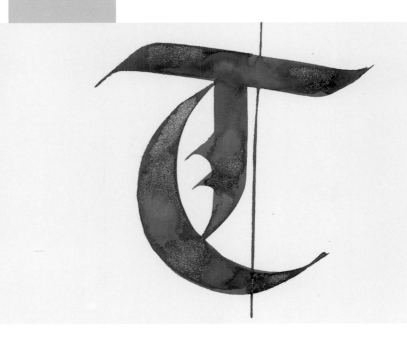

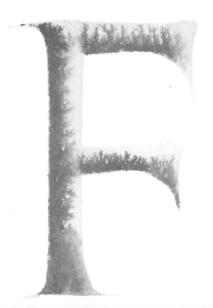

Rough blending

A fiery effect is achieved here by writing the F in water, running a narrow brush loaded with orange paint along one edge and yellow along the other.

MATERIALS

All-purpose cleaning cloth

Thin wood

Scissors

Masking tape

Watercolors

Paintbrush

Watercolor paper

Craft knife

Piano felt or balsa wood

Inks

HOMEMADE PENS, CUT IN FAIRLY WIDE SIZES FROM A VARIETY OF DIFFERENT MATERIALS, AND TREATED TO GIVE MULTICOLORED EFFECTS, OPEN THE WAY for endless experimentation in coloring letters. Here, we use cloth-covered wood and piano felt but any material which is absorbent enough to hold paint or ink and can be shaped into a usable "nib" will do just as well.

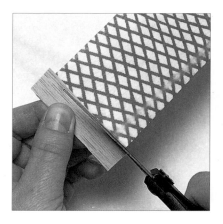

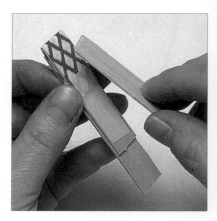

1 To make a pen, wrap a piece of smooth, all-purpose, absorbent cleaning cloth over a length of thin wood and cut through wood and cloth with strong scissors. You could use cardboard for this, but it will get soggy and wear out more quickly.

2 Secure the cloth to its piece of wood with masking tape, and encase this "nib" between two more pieces of wood to make a handle, holding it together with more masking tape.

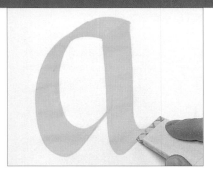

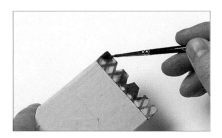

3 Add some light yellow watercolor to the nib of a wide cloth pen, and write a letter *a*.

5 Create a multiline pen by cutting notches into the nib of a cloth pen. Apply different colors to each section with a brush.

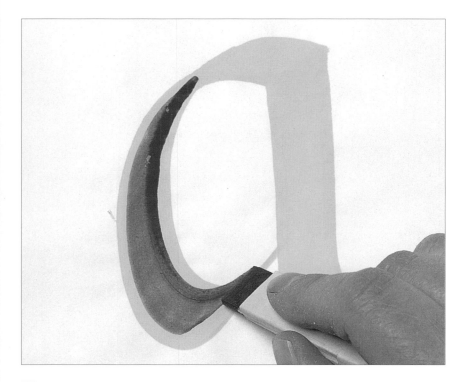

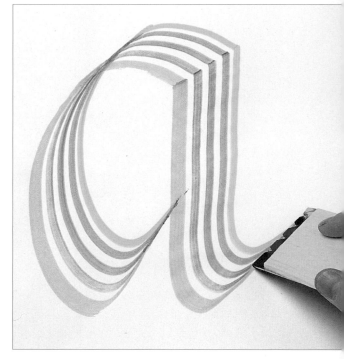

4 Taking a slightly smaller pen, write the letter *a* in the middle of the first one in a second color. Interesting effects can be achieved by adding the second color before the first is fully dry.

6 Write a large letter, making sure that all sections of the pen are in contact with the paper. The result is unusual and attractive.

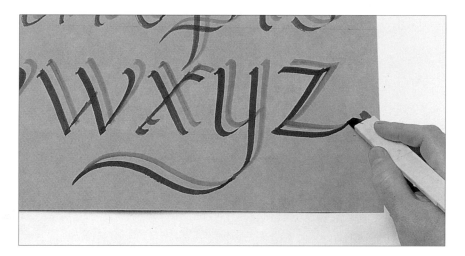

7 Apply different colors to each of the notches of a two-line cloth pen to produce a shadow effect.

8 Piano felt can also make a good pen. Use a craft knife to cut it to shape, tapering the writing end like a chisel, and apply paint with a paintbrush. Balsa wood can be used instead, but it is less absorbent than piano felt.

9 Brush three distinct stripes of colored ink or watercolor onto the felt pen. The color will soak into the fibers.

10 When the letter is written, the three colors will be visible but beautifully blended.

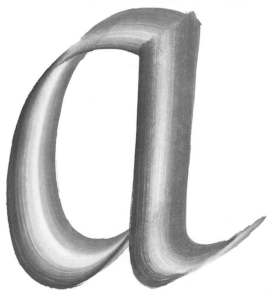

3–D effect

Three colors are painted onto a felt pen to make blended stripes and create a three-dimensional effect.

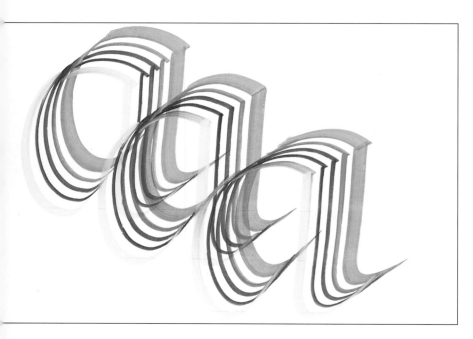

Overlay pattern

Each of the five notches of a cloth pen is painted with a different color. Note how the repeated letter makes a decorative overlay pattern.

Central stripe

This three-striped letter has a dark color applied over the central stripe using a narrower pen holding just a single color.

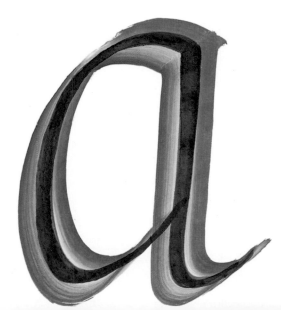

MATERIALS

Ink
Automatic pen
Layout paper
Colored paper
Gouache
Small paintbrushes
Palette

THE AIM OF THIS ALPHABET IS TO PRODUCE A SMOOTH TRANSITION OF COLOR THROUGH A LINE OF LETTERS. DIFFERENT COLORS ATTRACT THE EYE TO CERTAIN AREAS FIRST. FOR EXAMPLE, WHEN viewing red and yellow letters on a dark blue background, the eye will be drawn to yellow before it goes to red. This can be used to your advantage. Here, the gradual color variation from yellow through orange to red carries the eye smoothly through the alphabet.

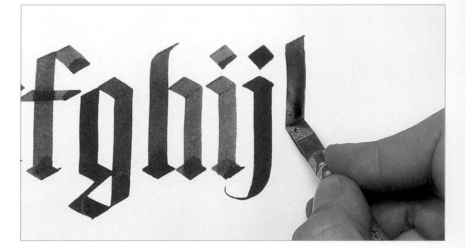

1 First choose your lettering style, in this case, blackletter. The pen angle for this is 30°. Practice the exact shape of each letter, using ink in an automatic pen on layout paper. When you are satisfied with all of the letters individually, design the composition and letter sizes.

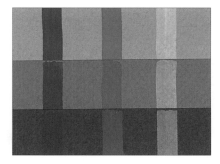

2 Use layout paper to trace the final letters and composition. Draw the *a* and move the top paper around, varying the space between the *a* on the top sheet and the *b* on the lower sheet until the space is balanced. The spaces between blackletters should be slightly wider than a vertical stroke, creating a regimented pattern within a piece of text. Continue this process with the rest of the letters. The alphabet has been divided into three lines placed close together to make the most of the patterned qualities of the letterforms.

3 When the alphabet is complete, figure out where it will sit on the piece of paper. A good general rule is to allow approximately equal spaces at the top and sides, with double that space below the design.

4 Experiment with different colored gouache on a variety of background colors before deciding which to use for the final alphabet. Add a little water to it and mix thoroughly with a paintbrush until the consistency resembles that of ink. Fill the automatic pen with gouache from the paintbrush.

41

5 Draw the letter *a*. If the gouache is too thick, it will not flow smoothly; if too thin, it will not produce an opaque finish. It is important to begin with quite a large amount of color – enough to complete the project, since matching the color halfway through will be difficult.

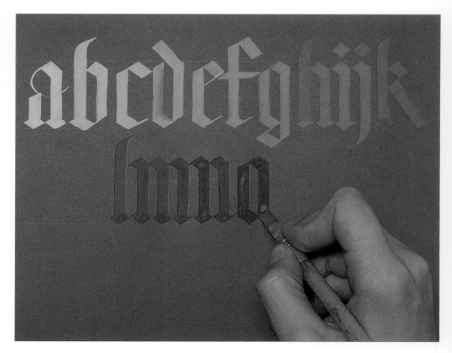

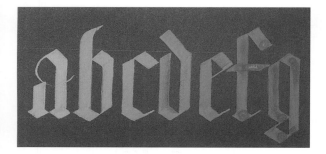

6 Before drawing the *b*, add a small amount of another color, taking note of the quantity added. Draw the *b*, and continue drawing the letters of the alphabet and adding the same quantity of the second color as previously noted until the mixture changes completely to the second color.

7 At this point, add the same quantity as before of a third color and continue drawing the alphabet. Here, yellow is used as the first color, and orange as the second. When the gouache mixture changes completely to orange, a third color – red – is added. The result is a smooth transition across the three colors, from yellow through orange to red.

Primary colors

Red and blue are used here with white. The white gives tonal contrast against the red and then, as it graduates to blue, the blue on red creates a vibrant color contrast.

Complementary colors

Red and green could be jarring but more neutral versions are combined here with yellow-orange to create a harmonious effect.

Tonal contrast

Two similar colors, violet and mauve, are given tonal contrast by the use of white, creating a soft, harmonious effect.

MATERIALS

Masking fluid

Dip pen

Hot-pressed paper

Sponge brush

Watercolors

Pencil

Ruler

Flat brush

THIS TECHNIQUE USES MASKING FLUID AND A GRADUAL CHANGE OF COLOR WITH EACH LINE OF WRITING TO CREATE AN ATTRACTIVE, REPEAT-PATTERN

alphabet. Always experiment with colors first to decide which ones are most suitable. Here, the masking fluid under the pale blue wash has a silvery sheen and is more effective than when used under silver paint.

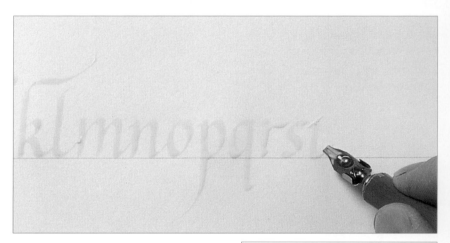

I Do some experiments to test the colors and techniques. To write with masking fluid, use a dip pen without a reservoir and watch out for stringiness in the fluid – keep cleaning the pen. It is possible to thin the fluid with a little water if necessary. Leave the masking fluid writing until it is completely dry.

2 Mix some paint and put a wash of color over the writing using a sponge brush. Leave to dry.

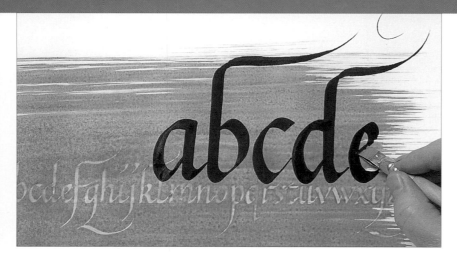

3 Try writing on top of the wash in other colors; this deep blue is effective on the bright orange.

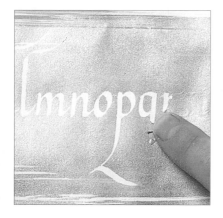

4 Carry out some trials, including masking fluid writing covered with a silver wash. Rub off the masking fluid to check the finished effect.

5 Now try a more controlled repeat alphabet. Lightly rule the exact number of lines needed for the repeats.

6 Write the first alphabet with masking fluid as before. When it is dry, apply a very pale blue wash by pulling a flat brush across the lettering. The alphabet will remain visible as the paint dries.

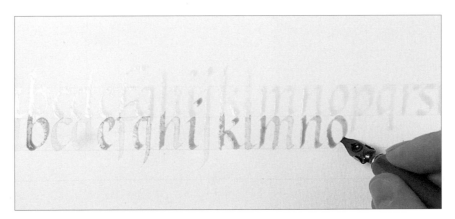

7 Strengthen the paint mixture by adding a little more blue, and use this to write an identical line of lettering immediately below the first. Allow to dry.

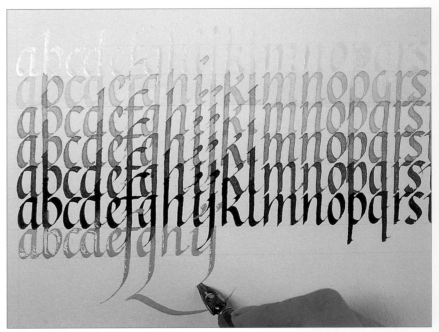

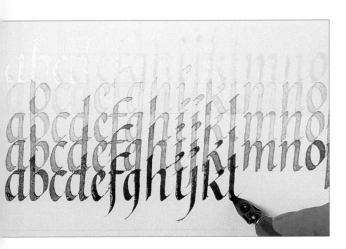

8 Gradually add more color at the start of each line, making it much darker toward the bottom of the page.

9 For total contrast, the last line is written in marigold yellow and finished off with a few flourishes. Clean off the masking fluid at the top to achieve the full light-to-dark effect.

Transparent paper

Vermillion is mixed with graduating amounts of white until the final line where black is added. The mottled transparent paper enhances the effect.

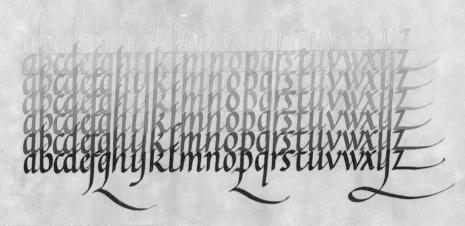

Marbled paper

Blue, green and silver marbled paper is the background for this set of green alphabets. The final row of silver provides an effective highlight.

Woodgrain

The woodgrain background is accentuated by the color of the alphabets, particularly the single line of dark brown.

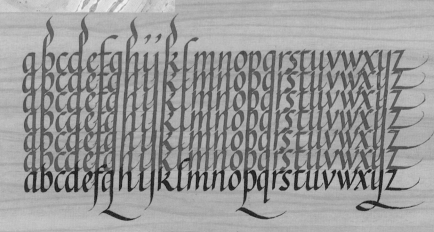

BACKGROUNDS

HERE SEEM TO BE NO END TO THE POSSIBILITIES FOR CREATING COLORFUL BACKGROUNDS ON WHICH TO PLACE YOUR CALLIGRAPHY. THEY CAN BE ANYTHING FROM a simple washed color, repeat or random patterning, to complex built-up effects which give an illusion of depth. The results can be as subtle or spectacular as required to enhance the mood of the composition.

MATERIALS

Watercolor paper

Gummed paper tape

Tray or sink

Water

Flat board

Sponge

Drawing pins

Watercolors

Palette

Large paintbrush

Tissue or blotting paper

A COLORED BACKGROUND ADDS INTEREST AND CAN HEIGHTEN THE IMPACT OF A PIECE OF CALLIGRAPHY. A COLOR WASH IS A SIMPLE AND EFFECTIVE way to achieve it. It can be used to create a straightforward single-color background or a striking multicolored one. You will enjoy this almost instantaneous technique, which does not take long to master.

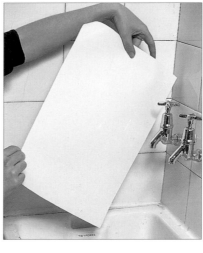

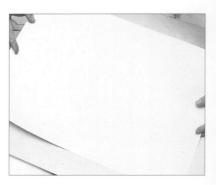

Stretching paper

1 Before applying watercolor or inks to the paper, it is necessary to stretch it to prevent warping or wrinkling. Cut four pieces of gummed paper tape to the correct lengths to fit around each side of the paper. Put some clean water in a tray or sink and submerge the paper evenly under the water. Leave it for one to two minutes.

2 Place the wet paper onto a board and lay it flat without rubbing the surface. Take care not to trap air underneath.

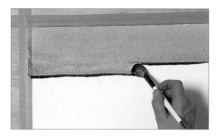

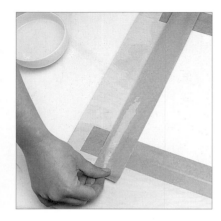

3 Dampen the gummed paper tape with the wet sponge and then place a piece of tape along each edge of the paper. It should overlap the paper by ½in (1cm). Place a drawing pin in each corner of the paper, through the tape. Leave the board on a flat surface away from any heat source for about six hours, or overnight, until the paper has dried.

Laying a flat wash

1 Choose a color for the wash, and mix sufficient paint to cover the paper. Apply the color to the stretched paper while it is still attached to the board. Tilt the board slightly toward you. Use a large brush in horizontal strokes across the paper and over the edge of the gummed tape. Each brushstroke should slightly overlap the previous one.

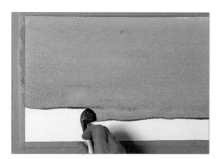

2 Reload the brush after each stroke, so that you do not run out of paint halfway through a stroke. Keep the strokes smooth and horizontal, but do not go back over a stroke again if it is uneven. This will not improve the stroke. Continue in the same manner down the paper.

3 Apply the wash quickly. The areas where strokes overlap will blend together, resulting in a uniformly colored background. If you run out of paint halfway through, it can be difficult to mix the same shade, and by the time this is done the half-finished background will be dry and thus prevent the additional color from blending with the first. This will cause a line where the two applications overlap.

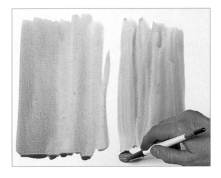

Laying a graduated wash

1 Start by testing different colors. Lay two broad strips of diluted watercolor onto some paper. Red and blue are used here.

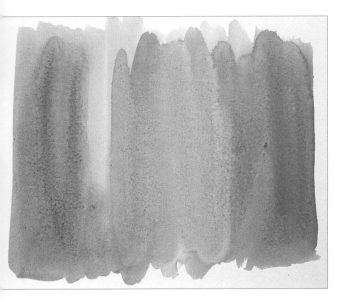

2 Overlay a third color in the central section where the two original colors meet. In this instance, the yellow over red produces a much more strident and bold effect; the yellow and blue blend together more subtly.

3 Decide which colors to use and prepare ample amounts of each, because speed is essential with this technique. Quickly apply the first color – in this instance yellow – using horizontal brushstrokes. Cover the whole of the stretched paper.

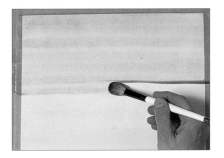

4 While the yellow ground wash is still wet, add the second color. Start at the top of the paper and work a third of the way down, blending the blue watercolor smoothly into the underwash. The second color should be strong enough to dominate the color underneath.

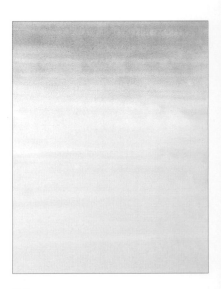

5 Dilute the second color a little more and continue to add blue to the middle section of the paper. By diluting the color and reducing the amount loaded onto the brush, the blue will blend into the ground wash, resulting in a smooth transition from blue to yellow.

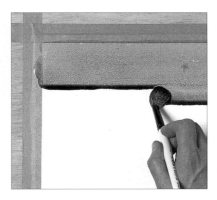

Laying a variegated wash

1 Begin with the same technique as before, applying one color at the top of the stretched paper.

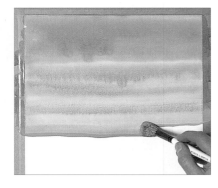

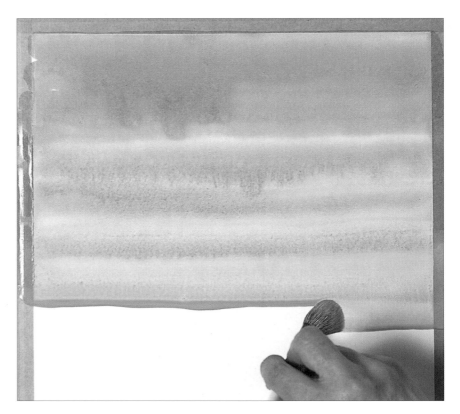

2 Approximately one-third of the way down the paper, introduce a second color. At the end of each stroke, reload the brush with the second color. The amount of the first color left on the brush will reduce with each stroke.

3 Continue to work down the paper. Tilt the board slightly if you want the colors to run into each other. If you prefer an even blend, wet the paper before applying the watercolor and keep the board flat. In this case, the choice of blue and yellow has created a green shade in the middle as the colors blend.

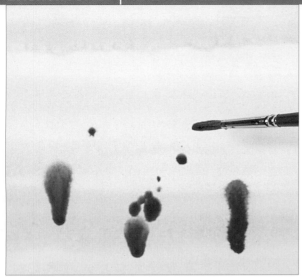

4 Create irregular background textures and effects by quickly adding brushstrokes or dabs of color to the background wash while it is still wet.

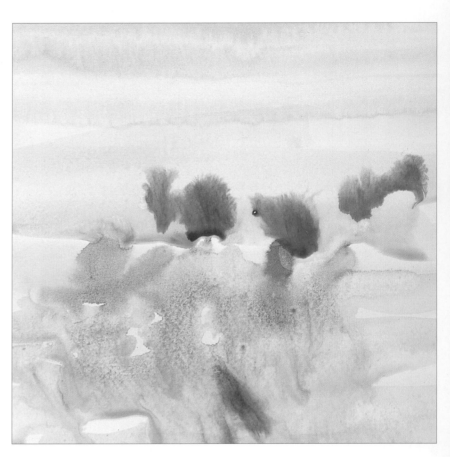

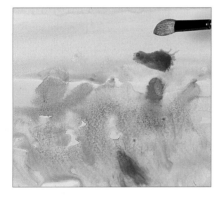

5 You can control, or stop, colors bleeding into one another by soaking up wet areas with tissue paper or blotting paper.

6 The newly applied watercolor gently bleeds and blends into the background wash. The wetter the background, the more blurred the effect. As the wash dries, subsequent additions of watercolor merge less and remain stronger.

Streaks of color

Monestral blue is applied over permanent rose in wide streaks of color. The combination of these two colors makes a striking impact.

Sedimentation

This variegated wash is in monestral blue, ultramarine and burnt sienna. Note the effect created where the colors have sedimented.

Atmospheric effect

Permanent rose and cadmium yellow merge in places to make oranges, creating atmosphere but with little sedimentation.

MATERIALS

Heavy watercolor or other
sturdy paper (stretched)

Gouache

Paintbrushes

Bowl

Shower and hand spray

Pens

Toothbrush

Bubblewrap

Saranwrap/cling film

Coarse salt crystals

Sponge

PAINTS SUCH AS GOUACHE CAN HAVE UNPREDICTABLE STAINING PROPERTIES, SO IF YOU LIKE ADVENTURE, YOU CAN HAVE FUN LAYING A WASH OF COLOR, WASHING SOME or all of it off again, and applying another layer on top to build up a textured background. Various kinds of plastic are then used to add yet more texture by using the plastic to manipulate the paint still further.

I Use heavyweight paper stretched on a board – it must be capable of withstanding rough treatment. Apply a colorful wash and leave to dry.

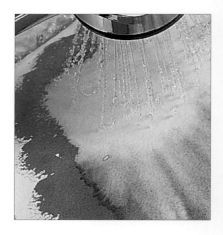

2 Hold the paper over a bowl and spray it with water. Regulate the shower spray depending on how much of the color you wish to remove. An even, all-over spray will create a pale wash, but if you concentrate on one spot, you can leave some of the original color showing.

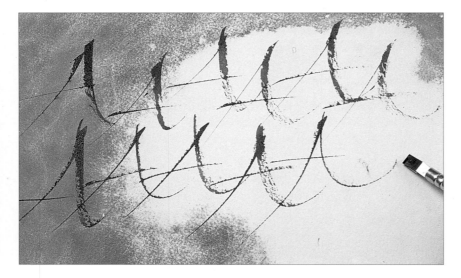

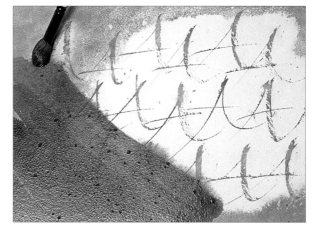

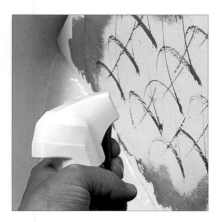

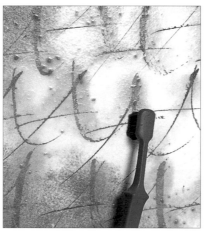

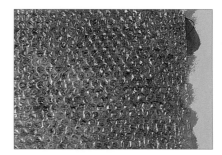

3 When the paper is dry, write or make marks across it to form the next layer of texture.

4 Use a hand spray this time to wash out selected areas – it will give you more control.

5 If the color stained more than you expected, and will not wash off enough, gently scrub over it with a toothbrush.

6 Apply a second overall wash of color. Here green is applied first, and blue patches dropped in.

7 Create more texture by laying some bubblewrap over the wet paint. Leave it until completely dry – this will take some time, since the moisture cannot evaporate through the plastic.

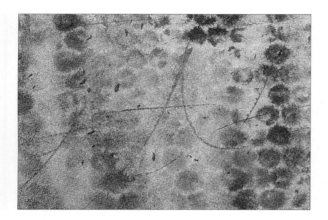

8 Remove the bubblewrap. Some of the letters from under the second wash will show through.

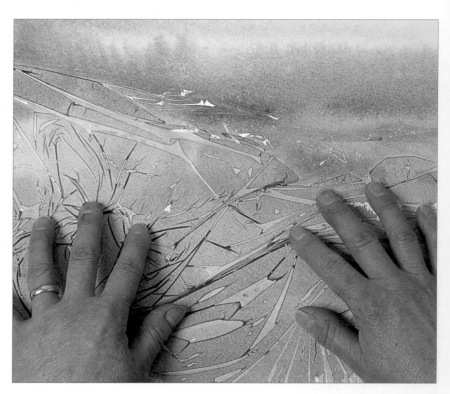

9 Alternative textural effects can be built up by starting with a similar uneven wash of color.

10 Place some saranwrap on top of the wet paint and push it around gently. Leave it in position until the paint is dry.

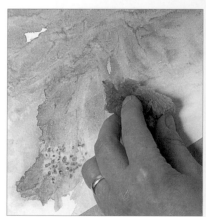

11 For increased texture, peel the transparent wrap back around the edges, sprinkle coarse crystal salt on top, and dab with thicker color. When it is completely dry, carefully sponge away the salt.

Salt crystals

The base wash is liberally sprinkled with salt crystals to produce a textural background that is a perfect foil for strong black calligraphy.

SCORPIO

Masking fluid

Inks are washed over masking fluid lettering to give a dark, atmospheric background. Once dry, the calligraphy is highlighted with gold.

Libra

Saranwrap

This thin wash of reds and mauve is given an individual character by the use of saranwrap. When dry, the calligraphy is written on top.

Sagittarius

MATERIALS

Waterproof inks

Glass sheet

Ink roller

Layout paper

Smooth-surfaced paper

Paintbrush

Craft knife

Repositioning spray

APPLYING INK WITH A ROLLER IS ONE OF THE EASIEST WAYS TO PRODUCE A COLORFUL BACKDROP SUITABLE FOR ANY PROJECT. YOU WILL have to practice this technique to learn how to control the application of the color, but once mastered you will be able to create a whole range of effects: overlapping colors and masking off areas are just two of a huge choice of striking designs.

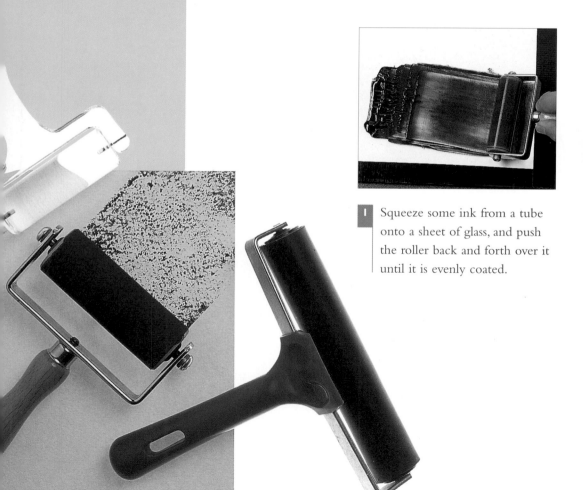

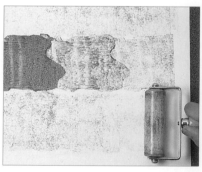

1 Squeeze some ink from a tube onto a sheet of glass, and push the roller back and forth over it until it is evenly coated.

2 Run the roller over the paper several times. One of the characteristics of this technique is that areas of the background paper show through the ink. Several layers can be built up.

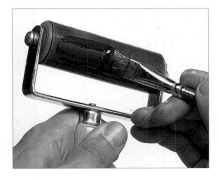

3 Alternatively, apply the ink direct to the roller with a paintbrush. Push the roller a few times over a piece of scrap paper to disperse the ink evenly; this also helps you to become familiar with the amount of color that you can apply with one pass of the roller.

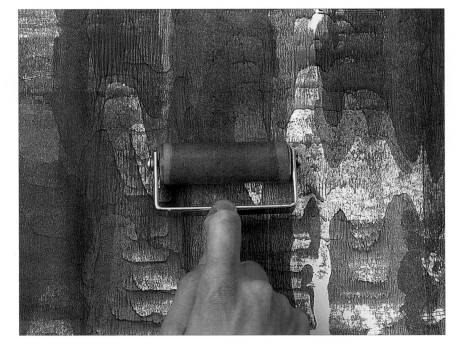

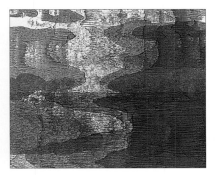

4 If the ink is unevenly spread over the roller, areas of strong and pale color will result, which can be used to advantage.

5 Leave the ink to dry. Then choose a second color to roll over the first, perhaps in a different direction.

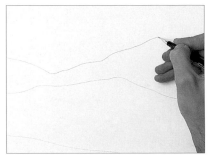

6 Now that you have experience and control over the application of color, try producing a simple stenciled background with it. Draw the outlines of a hilly landscape on layout paper.

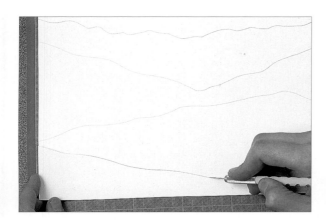

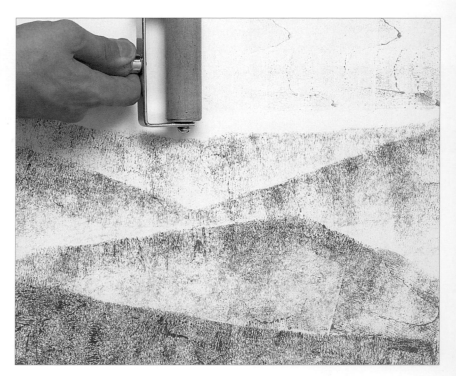

7 Cut out the shapes with a craft knife to create a stencil, and apply repositioning spray on the reverse. This allows you to peel the paper off and lay it down smoothly on top of the actual background paper for rollering.

8 Place the prepared stencil on the paper and remove the first section, leaving the rest of the paper masked. Roll the paint in several directions until you achieve the density you want.

9 Remove the next section of the stencil and roller over this area. Continue until all of the stencil has been removed, slowly building up a picture. Aim to produce a consistent, light covering with each pass of the roller but apply heavier color to the edges of each stencil shape to emphasize the design.

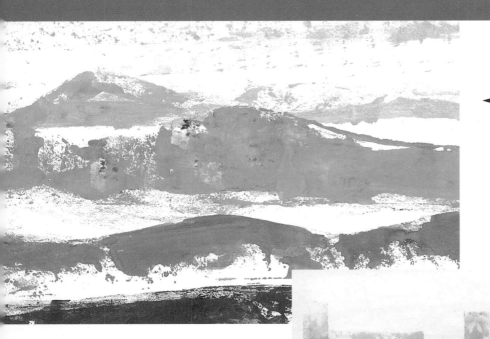

Cardboard cutouts

An evocative scenic effect is created here by rollering various colors over cardboard cutouts.

Multiple layers

Several inks rollered in different directions combine to make rusty oranges and browns. Thick gold is applied once the other colors are dry.

Textural effect

The texture is achieved by using thick gouache rollered one color over another. The colors used are monastral green, cerulean blue and white.

MATERIALS

Layout paper
Nonwaterproof inks
Paintbrush
Bowl of water
Newspaper
Drawing paper
Watercolors
Automatic pen

A COUPLE OF EXPERIMENTS WITH THIS METHOD FOR PRODUCING UNUSUAL, IRREGULAR BACKGROUNDS WILL ACQUAINT YOU WITH THE EFFECTS that can be achieved. From subtle one-color markings through dynamic backdrops created with many hues, you will be delighted by the results of this simple and adventurous technique.

1 Scrunch up a sheet of layout (or slightly heavier) paper into a tight ball.

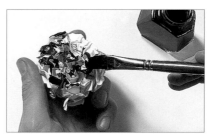

2 Apply ink to the outside of the crumpled paper ball with a paintbrush. The ink will run between the gaps and also seep into the paper where it folds.

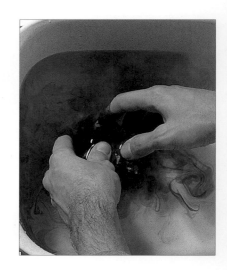

3 Immerse the paper in a bowl of water for a few seconds and unfold partly. The ink will start to run immediately. Do not worry if the paper tears a little as you open it.

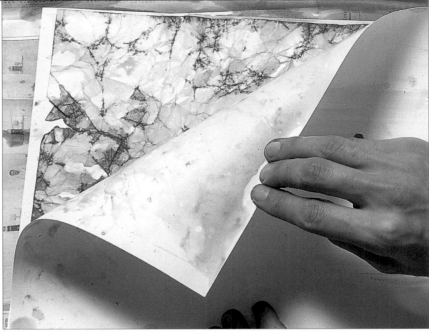

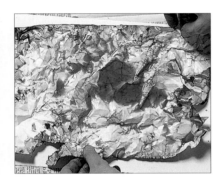

4 Quickly lift the paper out of the water, unfold it fully and place it on a sheet of drawing paper. Make sure that the table is protected with old newspaper.

6 Carefully peel away the top piece of drawing paper and then the inked paper.

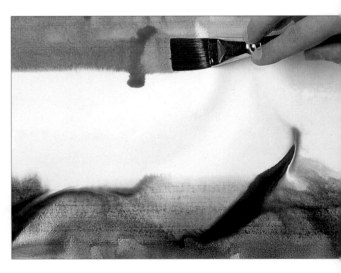

5 Lay a second piece of drawing paper on top. Press the sheets of paper together with your hands, working from the center out to the edges.

7 Leave both sheets of drawing paper to dry completely. Each sheet will have a slightly different spread of color.

8 Add a further layer of color if desired. Brush two broad bands of watery paint across a piece of layout paper, making sure they go on very wet.

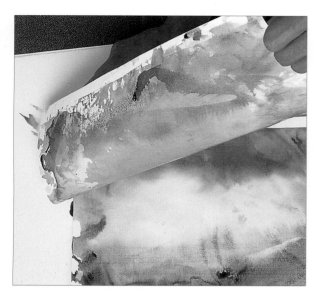

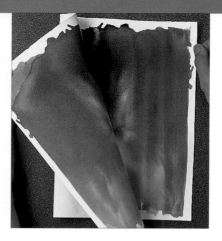

11 Fold the paper in half again and press all over. The pressure will increase the blending.

9 Place the dried sheet of drawing paper face down over the wet paint, and press carefully all over. Peel it back carefully and see how much color has transferred.

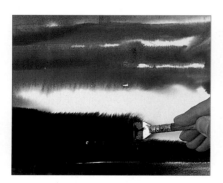

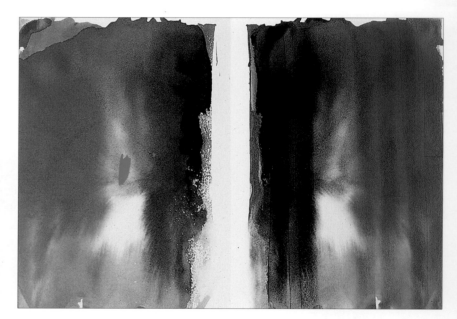

10 Another approach is to fold a sheet of drawing paper in half, wet it thoroughly and apply ink or paint to one half only with an automatic pen. The water will make the colors merge together where they meet.

12 Open out the paper carefully and leave to dry. You will have a pair of backgrounds which are mirror images of one another.

Crumpled paper

This background is made by crumpling a sheet of paper, applying it with dark ink, and then placing it on top of a piece of wet red card.

Soft and sharp edges

Several colors are applied to crumpled paper which is then pressed onto both dry and wet surfaces, giving contrasting soft and sharp-edged textures.

Mirror–image print

This striking effect is achieved by drawing streaks of color with an automatic pen on wet paper, and then folding it to create a mirror image.

67

MATERIALS

Watercolor paper (stretched)
Black waterproof ink
Automatic pen
Acrylic inks or gouache
Paintbrushes
Coarse salt crystals
Sponge

PAINTING BACKGROUND COLORS AFTER THE LETTERS ARE WRITTEN MAY SEEM TO BE THE WRONG WAY AROUND, BUT IT WILL ENABLE YOU TO respond to the shapes already created on the page. You may prefer to apply color carefully to each letter, or more freely, as demonstrated here, allowing the paint or ink to run and merge.

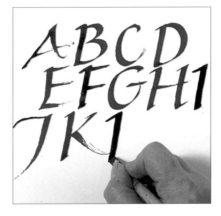

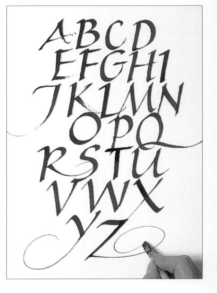

1 Use black waterproof ink and a large automatic pen to write an alphabet, creating a balanced design on the paper. Leave to dry completely before applying the colored background.

2 Some preplanning is necessary, but in this example the letters were written freehand. If you rule lines for a more careful arrangement, erase them before applying the colors.

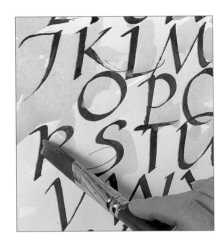

3 Test your intended colors to check how well they blend. Here, acrylic inks were used; for a softer effect, gouache would be a good choice.

5 Consider where to place extra color for an overall balance, both in and around the letters.

7 The salt will soak up some of the water and leave patches of white. You may need to add more crystals if the first results are not satisfactory.

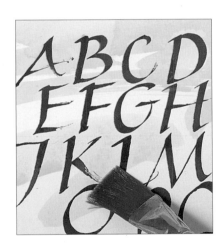

4 Lay the work flat. Wash the first color on freely with a large brush, adding water in places to create lighter areas in the design.

6 For a textural effect, sprinkle coarse sea salt crystals over some wet areas and leave to dry.

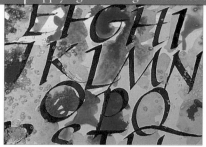

8 Look again at the design, and plan where to apply another color. Choose the areas carefully and control the merging of the colors as much as possible.

9 Sprinkle on more salt over the new application of color if desired. Leave to dry.

10 Sponge off the salt very carefully to reveal the patterns where it has soaked up the paint.

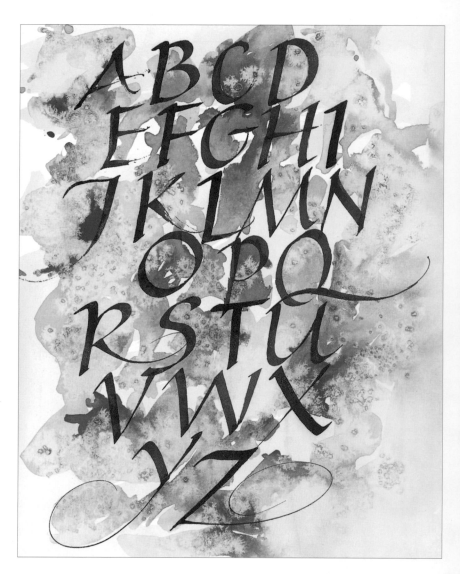

11 The finished piece shows alphabet and color fully integrated. This technique also lends itself to more restrained approaches, where calligraphy and background are designed with precise measurement, and color is painstakingly filled in.

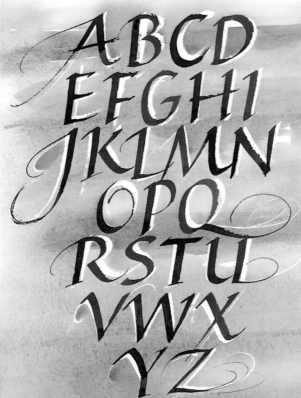

Blended colors

The blue and purple washes are very watery and blend together well to produce a subtle result. Extra texture is created with salt crystals.

Analogous colors

The green alphabet is washed afterwards with analogous greens and blues. The washes are not very watery and so remain fairly distinct.

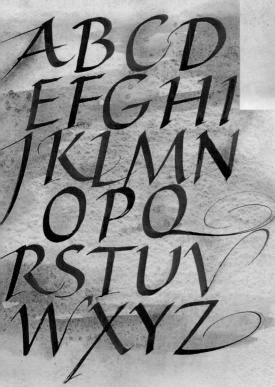

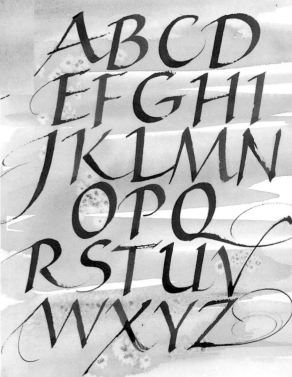

Masking fluid

An alphabet written in brown acrylic ink is left to dry and then rewritten offset in masking fluid. After the washes are added, the masking fluid is rubbed off.

MATERIALS

Automatic pens
Blue and black ink
Layout paper
Dark blue drawing paper
Fiber-tip pen
Pencil
Ruler
Water
Bleach
Small mixing dish

A PICTORIAL EFFECT CAN MAKE A STRIKING BACKDROP TO A SMALL AMOUNT OF TEXT. THIS EXAMPLE CREATES AN IMAGE OF TOWERING SKYSCRAPERS, reminiscent of a city skyline by night. The impression is enhanced by using different-sized nibs and various shades of ink to convey distance and depth. Bleach lettering and highlights complete the cityscape illusion.

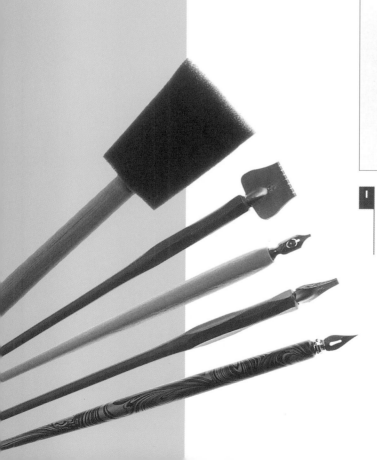

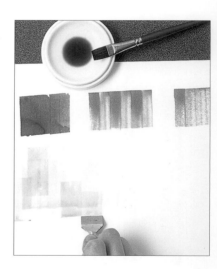

1 Practice some vertical strokes, using an automatic or wide poster pen with dark blue ink. Butt the lines together.

2 Notice how different effects can be achieved depending on the amount of ink in the pen: even or streaky, and graded as the ink gradually runs out.

3 Overlapping the strokes creates an illusion of three-dimensional depth, and provides the inspiration for this project.

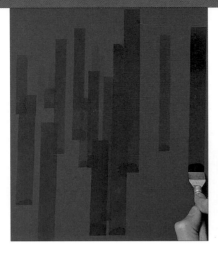

5 Using a wider pen with a greater intensity of ink, draw more strokes and create the beginnings of depth.

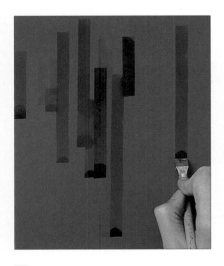

4 A longer version of the same strokes on a dark blue paper gives a striking start to the picture. Make them with watery blue ink. Leave gaps between some and overlap others.

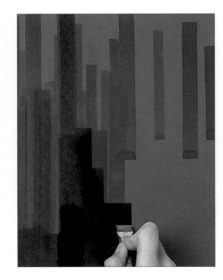

6 Build up the image with increasingly large nibs. Mix the blue ink with a little black each time you change pens so that the top layer appears to come forward from the previous ones.

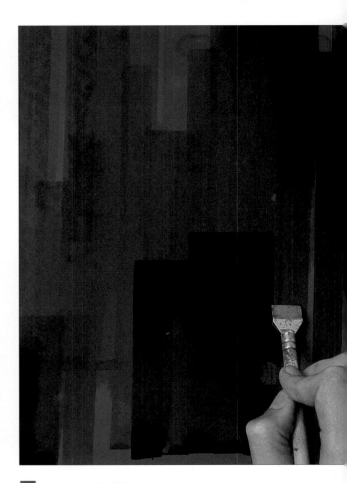

7 Continue building the layers with bigger pens, using solid black ink for the final strokes. Denser strokes of color are applied to the lower half of the paper to give the impression of very tall skyscrapers rising above surrounding smaller buildings.

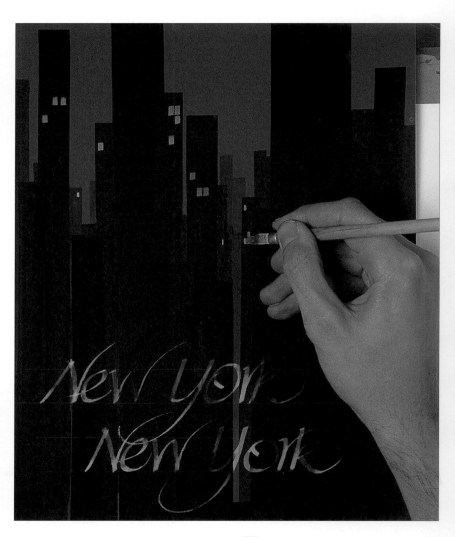

8 Design the lettering that will go over the background, on layout paper. Use a fiber-tip pen for your first thoughts, but choose a suitable metal pen that will stand up to bleach for the actual piece. When you are satisfied with the composition and layout, rule guidelines with a pencil on the background.

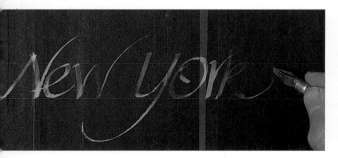

9 Mix a solution of 4 parts water to 1 part bleach in a small container. Using this as the ink, write the words over the background. Highlights will arise within the letters where the bleach touches lighter shades of the background.

10 Complete the illusion by adding lit windows – regular small strokes of bleach solution. You might like to create a composition with more sky, and add stars or the moon.

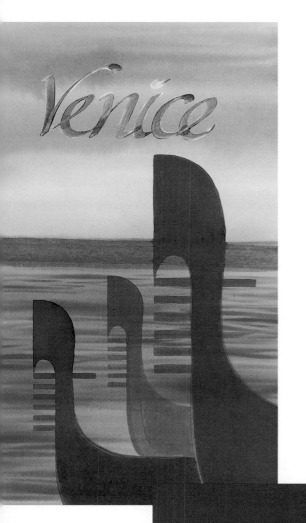

Different width pens

The black ink on red mountboard background is drawn using wide and narrow pens. The lettering is in ink and bleach.

Graphic shapes

An overall wash is followed by streaks with an automatic pen. Strong graphic shapes form the ends of the gondolas.

Pen outlines

A pen is used to apply a base wash and to draw the outlines of the shapes which are then filled in with a brush.

MATERIALS

Gouache

Mixing palettes

Sponges

Water

Paper

Conté chalks

Craft knife

Colored cardboard

Sponge brush

Watercolors

SPONGING IS EASY TO LEARN AND CAN BE USED WITH CALLIGRAPHY IN COUNTLESS WAYS. A NATURAL SPONGE IS PREFERABLE TO A SYNTHETIC SPONGE BECAUSE

its irregularity produces interesting patterns and textures but any type can be used successfully. All you need is a sponge and differently colored paints to produce a variety of interesting textures and backgrounds.

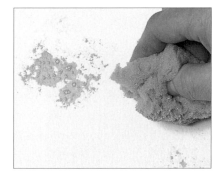

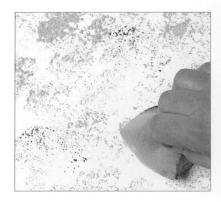

1 Prepare a thin layer of gouache on a large flat palette or saucer. Immerse the sponge in water and squeeze most of it out, leaving the sponge damp. Dip the sponge into the paint and experiment with dabbing the paint onto a piece of scrap paper. Too much paint on the sponge will create heavy blobs. After a couple of tests you will know the correct amount of paint and pressure to apply.

2 Gently sponge the first color onto the paper. Take care not to drag or smudge the paint – just lightly dab the sponge onto the paper and lift it off vertically immediately. If you intend to use more than one color, space out the sponge prints. Introduce a second color in the same way.

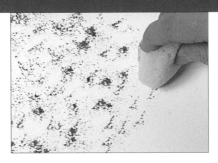

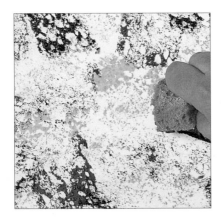

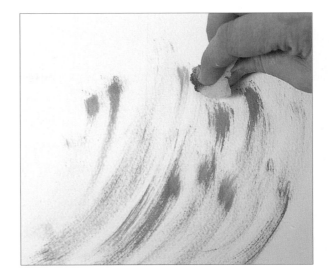

3 To create a multicolored but uniform background, apply third and fourth colors with similar spaces between the prints.

5 Smaller dabs of more muted colors create a more subtle background. It is important to mix the paint to the correct consistency. When using gouache, the mixture should be more watery than that used for lettering. If it is too thick, drawing letters over the dried paint will be difficult.

6 A "stormy" background can be created by dragging the sponge across the paper in bold streaky movements rather than dabbing the color onto the surface.

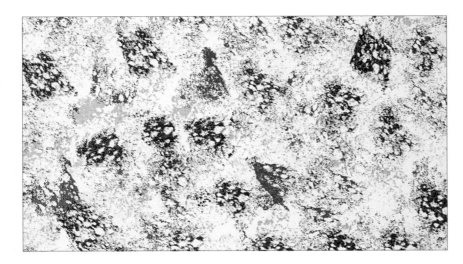

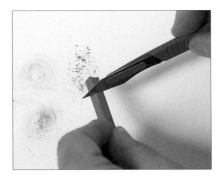

4 Stand back from the surface and check to see if some areas lack a particular color. Add more of the first, second, or third colors, as necessary, to create an evenly colored background.

7 A sponge can be used as a dry tool to manipulate color rather than to apply color. Scrape some conté chalk onto the paper in a small heap using a craft knife.

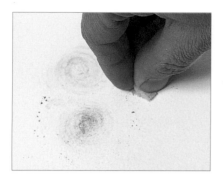

8 Using a small piece of dry sponge, press the conté into the paper, twisting it so that the colors form small swirls.

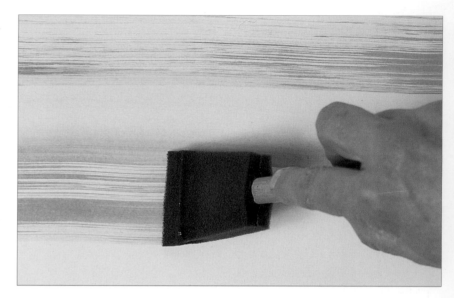

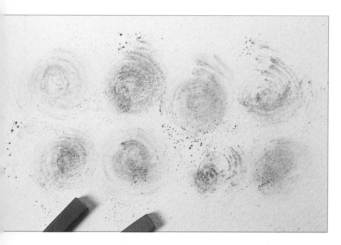

9 Try it with two colors in a regular pattern or use more colors in a random design. You will need to spray the finished background with fixative to prevent the colors from smudging or brushing off.

Sponge brushes

1 Use a base of colored cardboard or stretched color-washed paper. Mix sufficient amounts of watercolors in separate palettes. Dip the end of the sponge brush into the watercolor and drag it over the surface. You may want to practice on a piece of scrap paper first.

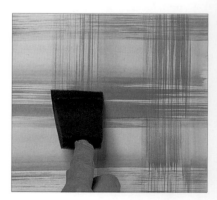

2 Create whatever patterns or shapes you think suitable for your background. Here, a simple checked pattern is produced by turning the paper 90° after sponging the first parallel lines.

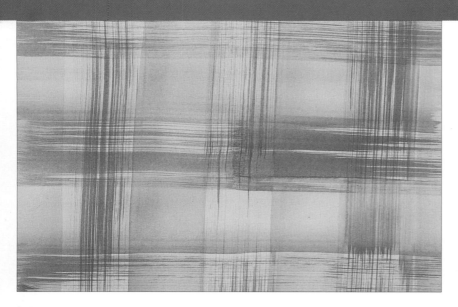

3 Paint lines between the red
strokes, using another sponge
brush with water, or a similar
color to the original surface.
This will soften the edges of
the red stripes. Do not go over
any strokes more than once, or
they will stand out too much
from the rest.

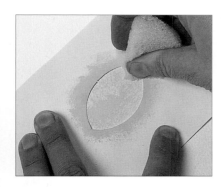

Sponging through a stencil

1 Choose a stencil, lay it on the
paper and dab some watercolor
through it with a sponge.

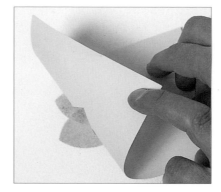

2 Exploit the transparent nature of
watercolors (and some inks) by
overlapping stenciled shapes.
Using a slightly different color,
stencil a second image halfway
across the first. Allow the first
color to dry before applying
a second one.

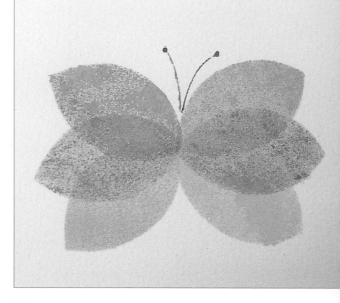

3 The completed image has been
turned into a stylized butterfly
by the addition of drawn
antennae. This stencil could also
be used to create a flower.

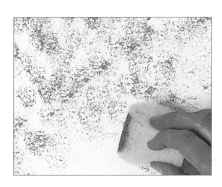

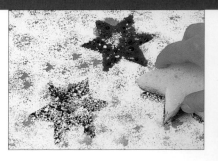

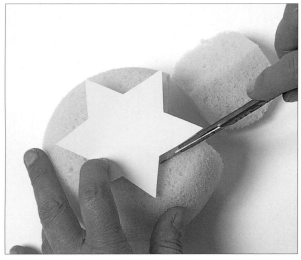

3 Dip one of the offcuts of sponge into some thin, watery paint. Squeeze out any excess to prevent blobs of thick paint, and dab color lightly over the paper to create a pale first layer.

4 Coat one surface of a star sponge with a color that is stronger than but blends well with the initial background. Press it carefully onto the page, making sure all the star's points make contact with the paper. Lift off cleanly, and repeat several times over the paper.

Printing with a sponge

I Cut out a paper star shape to use as a template. Lay this on top of a thick sponge and cut around it with a craft knife. Cut right through the sponge, keeping any leftovers for other projects.

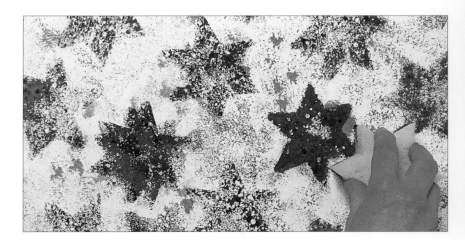

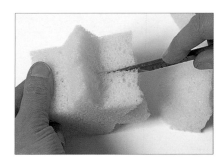

2 Cut the star-shaped sponge into two pieces. Make sure that the cut surface is even.

5 With the other star, use another color of similar strength to print more stars. Overprint some of the stars when the paint begins to diminish in strength to produce a ghostly effect. If the effect is too strong to write over, it would serve well as endpapers in a handmade book.

Circular texture

For an overall texture, cerulean blue, ultramarine and moss green are printed using a circular shape cut from a commercial sponge.

Radiating circle

Hot colors are used with a rectangular sponge, printed in a radiating circle to give a spectacular effect.

Petals and leaves

Two shapes are cut from sponge. One is a petal shape to form the flowers, the other is used to create the leaves.

MATERIALS

Conté crayons
Craft knife
Cardboard
Stencil brush
Hot-pressed paper
(stretched)
Perforated material to act
as a stencil
Spray fixative
Gouache
Small mixing dishes
Sponge or paper towel

HERE ARE TWO VERY DIFFERENT BACKGROUND EFFECTS, EACH USING STENCILING METHODS. THE FIRST IS CREATED WITH AN EXISTING, READY-made stencil; the second stencil is an individual design. The results are easy to control, and can provide a background with a regular overall pattern, or a graded pictorial effect.

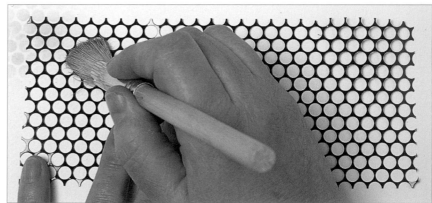

Ready-made stencils

1 Scrape a conté crayon with a craft knife over a scrap piece of cardboard to make a little pile of dust. Press a stencil brush into the pile, working it around to pick up the color. Choose a ready-made stencil, such as this piece of waste from sequin manufacture. Position it on your paper and hold it firmly with one hand. Dab the stencil brush through the holes.

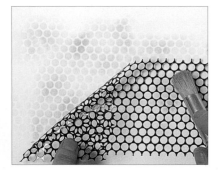

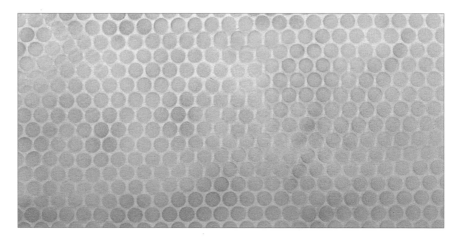

2 Work carefully across the stencil, recharging the brush with more color from the scraped pile and using firm dabbing movements to transfer color into the honeycomb holes. Fold back the stencil gently to check how the pattern is emerging. A second, darker color can be added at this stage.

4 Take care not to smudge the finished background. Spray it with fixative before writing any calligraphy on top.

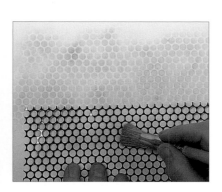

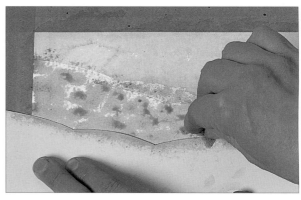

3 If you want a larger area of pattern, move the stencil down and carefully line up the holes before blending in the colors. Always begin with lighter colors, adding darker ones for contrast and interest.

Homemade stencils

1 Try making simple stencils of your own design. Draw a few lines on some thin cardboard to suggest a landscape. When satisfied with an outline shape, cut it out with a craft knife. This edge is your stencil.

2 Mix a few dishes of watery, muted gouache colors. Position the cut edge of cardboard near the top of the paper, and apply one color with a piece of sponge or paper towel, dabbing evenly all over the area and up to the edge of the stencil.

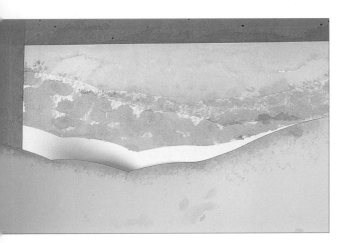

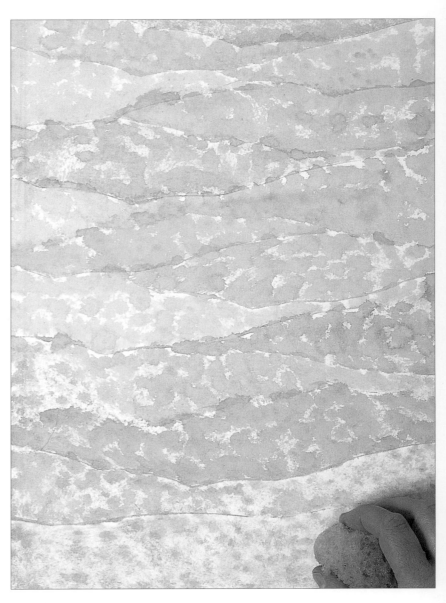

3 Allow paint and stencil to dry. Move the stencil down and to one side (to avoid parallel lines), and apply the next color.

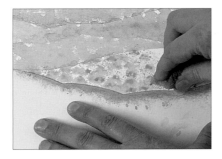

4 Proceed in this way down the page, changing color each time. Avoid too much contrast between adjoining colors – each can be overlapped onto the previous area to blend a little.

5 Use the same sponge throughout to accumulate the colors and assist in the blending. The finished background effectively gives the impression of a rolling landscape.

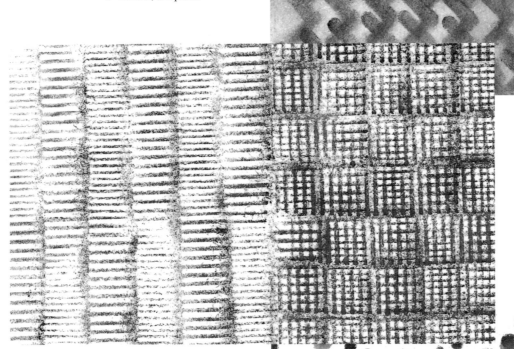

Potato masher

Conté chalks are rubbed through the holes of a potato masher repeatedly. The conté produces a soft effect; for more precise outlines, use paint.

Metal comb

Two different colors are stippled through a narrow-toothed metal comb. This unusual stencil creates a variety of textural effects.

Coffee filter

Magenta paint is stippled through the metal part of a coffee filter, and then yellow stippled offset from the first color.

MATERIALS

Gouache
Watercolors
Masking fluid
Paper or cardboard
Toothbrush
Large flat paintbrush
Automatic pen
Palettes
Scrap of thick cardboard

USING UNUSUAL TECHNIQUES TO APPLY PAINTS AND INKS CAN CREATE MANY INTERESTING RESULTS. SPATTERING PAINT ALLOWS YOU TO BUILD

up the density and color mix of a background gradually, while remaining in total control. Spattering and writing letters in masking fluid on top of a watercolor wash is a simple and effective variation.

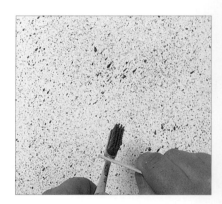

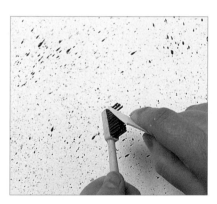

1 Choose a sheet of paper or cardboard, and a set of gouache colors. Mix the colors in palettes. Dip an old toothbrush into a color and hold it over the paper with the bristles facing upward. To flick the paint onto the paper, drag a small piece of thick cardboard over the bristles, from the tip that is nearest the paper toward yourself.

2 When you have applied enough of one color, add a second, and then perhaps a third. Using a number of colors is effective, but putting too many in any one area will probably produce dull, muddy tones. Try using various types of brushes to achieve different results. Stiff brushes, such as stencil brushes, are a good choice.

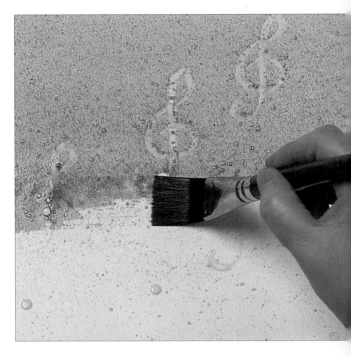

3 Lay a pale, flat watercolor wash over a sheet of cardboard or paper. Leave to dry.

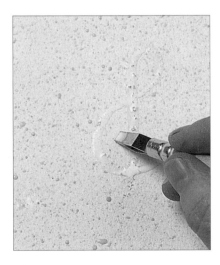

6 When the masking fluid is completely dry, lay a slightly darker watercolor wash on top with a large flat paintbrush.

4 Using a toothbrush and the same method as before, flick small blobs of masking fluid over all areas of the background.

5 Add some lettering or abstract marks, also in masking fluid, applied with an automatic pen.

7 Flick colored gouache from the toothbrush evenly over the entire background area.

8 Two or three colors work well. Aim for some consistency in the size of the paint droplets. This will be easier if you do not overload the brush – too much paint can make over-large spots.

9 When the paint is completely dry, carefully remove the masking fluid with your finger. Rub gently over the area and the fluid will peel away, revealing the color of the first watercolor wash.

Random spattering

Random overall spattering of several colors is then spread by dropping in water from a brush.

Varying densities

Garden leaves are laid on the paper, and then colors spattered across in varying densities.

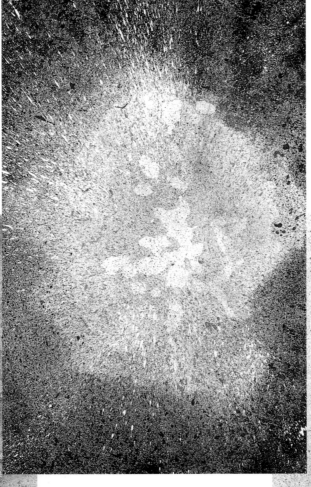

Radiating pattern

Masking fluid is spattered first and then colors are spattered in a radiating pattern, increasing in depth toward the edges.

MATERIALS

Gouache, watercolors and inks

Automatic pen

Watercolor paper

Ruling pen

Two pencils

Rubber band or tape

Eraser

Open-weave material

Paintbrushes

CROSSHATCHING CAN CREATE A VARIETY OF INTERESTING MARKS AND TEXTURES THAT WOULD BE DIFFICULT TO PRODUCE BY PAINTING. OTHER WAYS OF achieving crisscross lines, such as printing open-weave materials onto the background, make an unusual textural effect. Crosshatching is also a simple way to produce multicolored lettering.

1 Using a very pale ink or paint, write a large letter with an automatic pen. While this is drying, mix a stronger series of colors to create the background of crosshatching.

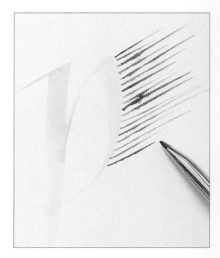

2 Utilize the first color to make freehand parallel lines with a ruling pen, starting from the edge of the pale letter. Take care not to go over the edges of the letter anywhere.

3 When that is dry, apply another color in a different direction, still keeping the actual letter pale. As you build up the crosshatching, the letter will become more defined.

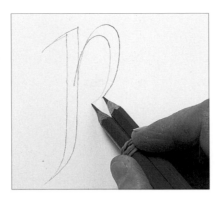

5 To make the actual letter from crosshatching, fix two pencils together with a rubber band or tape and draw the outline.

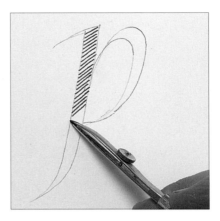

6 Draw parallel lines within the letter, freehand or with a ruler, and allow the color to dry.

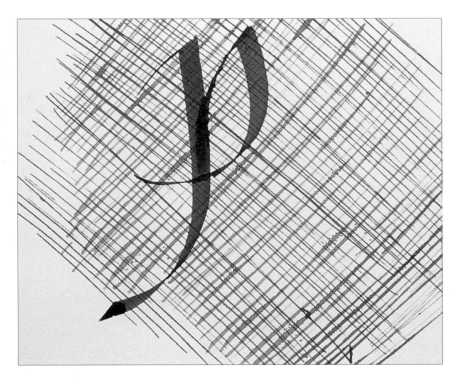

4 Alternatively, complete the background of crosshatching first, and write the letter on top.

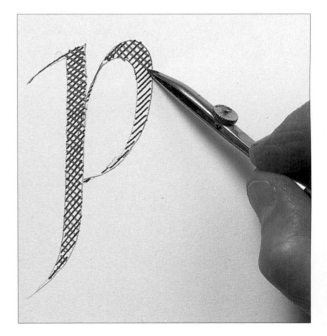

7 Crosshatch carefully with a second color. When this is dry, erase the pencil lines.

10 Peel back the material to reveal the pattern. Repeat if you want more texture.

8 A textural crisscross background can be created using a piece of open-weave cloth. Lay a colorful background wash, then apply the dampened material and press it down well.

9 Add some thicker paint, dabbing it through the weave. The more paint you use at this stage, the more intense the pattern will be. Leave to dry.

11 When the lettering is complete, add small patches of crosshatching around and between the letters. Areas of heavy texture made by the open-weave material can be highlighted with gold gouache to give the piece sparkle.

Plastic mesh

First, a plastic mesh is laid over an acrylic wash. When dry, the lettering is added. Crosshatching is then applied carefully to emphasize the mesh.

Masking fluid

The crosshatching here is applied on top of a watery wash after the lettering has been written in masking fluid.

Two-tone hatching

Here, the crosshatching in blue blends into the background while that in gold stands out as a foreground, giving depth to the piece.

MATERIALS

Stretched paper
Cardboard
Scissors
Gouache
Paintbrushes
PVA glue

RAISED AND TEXTURED SURFACES, PARALLEL LINES, REGULAR AND TWISTED PATTERNS – THESE ARE JUST SOME OF THE WONDERFUL EFFECTS YOU can achieve with this fun method. You need to use robust paper for these experiments, to withstand the pulling, twirling, and scraping of many layers of color across the surface.

1 Apply a colored wash to stretched paper or cardboard, and leave to dry.

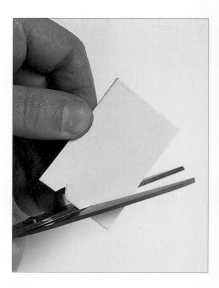

2 Take a piece of cardboard to use as a scraping tool, and cut some nicks out of the edge.

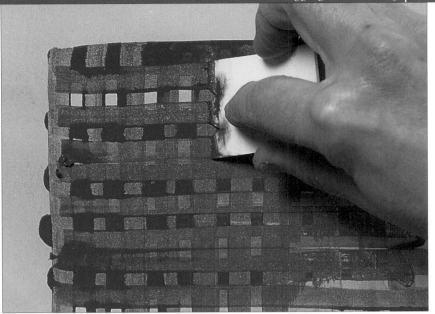

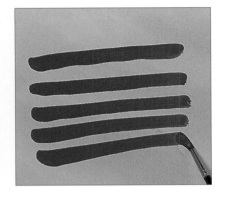

3 Load a brush generously with paint and apply streaks of color across the background wash.

5 Build up more layers by repeating the painting and dragging as often as desired.

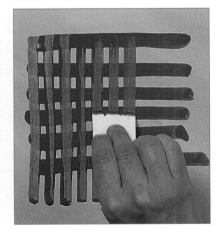

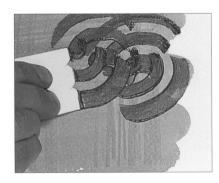

4 Drag the cardboard scraper across the streaks, so that they run into each other to create a woven effect.

6 Instead of applying streaks of color with a paintbrush, you can use the cardboard scraper. Put a generous amount of paint on the scraper with a paintbrush, and recharge it frequently. Try sweeping the color on freely with a twisting movement.

7 Here, paint is laid on thickly with a plain piece of cardboard. The background color will show through to varying degrees, depending on the degree of pressure applied.

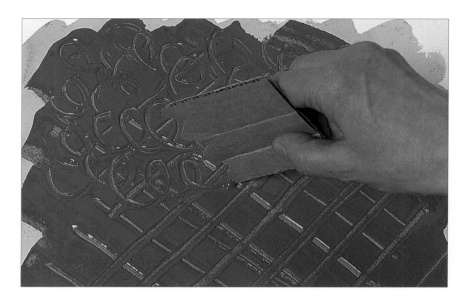

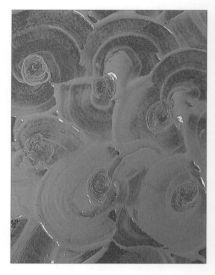

8 Scratch through this layer with other implements to reveal more of the underlying color; you can choose how much to reveal.

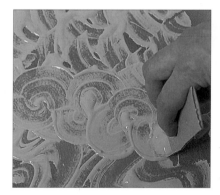

9 Now try a dark base color that will have a lighter hue scraped over the top. Lay a rough wash of color across the paper and leave to dry.

10 Mix 1 part pale-colored gouache to 3 parts white glue. Scoop some of the mixture up with a stiff piece of cardboard. Drag it over the background color in a swirling pattern.

11 Here, thick layers have been dragged and twisted across the paper. When this dries it will be too thick to write over except with a brush, so a thinner mixture would be advisable in the writing area. An advantage of using PVA glue in the background, however, is that it seals the surface when dry, allowing you to write on top without the characteristic bleeding that often occurs when writing over a layer of paint.

Multiple layers

*A watery wash underlies
a circular repeat pattern
made with an automatic
pen. The final layer of
criss-crossed ink is made
with a wide-toothed comb.*

Thicks and thins

*Red ink is swirled across
the checked background in
sidewise movements with
a wide-toothed comb.
Constant recharging
creates thicks and thins.*

Rough texture

*A woven, rough texture is
achieved by mixing blue
gouache with PVA glue
for extra body. Gold is
dropped in randomly
during the dragging.*

COMBINED

 OU MAY OFTEN FIND IT APPROPRIATE TO COMBINE ONE TECHNIQUE WITH ANOTHER TO GAIN MAXIMUM ADVANTAGE FROM THE QUALITIES OF EACH. TRY SOME OF the following examples, then see what other ideas occur to you that could also be combined. The main thing you must try to do is bear in mind the materials you have and exploit their properties to the fullest.

MATERIALS

Masking fluid
Paper
Paintbrush
Ruling pen
Automatic pen
Colored cardboard
Watercolors

MASKING FLUID DRIES TO CREATE A TEMPORARY MASK TO PROTECT PRECISE AREAS AND SHAPES, SUCH AS LETTERS. YOU CAN APPLY IT LIKE PAINT, using a brush, or treat it like ink in a pen. It is invaluable for enabling lettering to stand out clearly against a colorful or "busy" background and can be used underneath any medium.

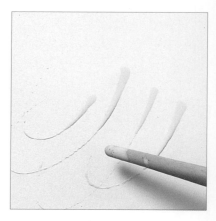

1 Become familiar with the properties of the masking fluid by experimenting with different tools. Dip the wrong end of a pen or brush in the fluid and make marks on a sheet of paper.

2 Dip a ruling pen into the liquid and create some flowing lines and calligraphic flourishes.

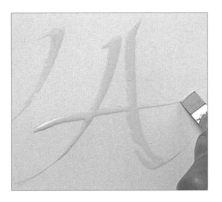

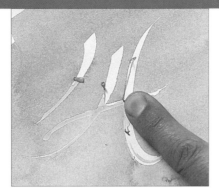

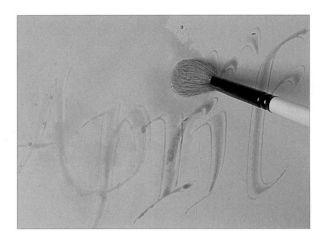

3 Use the fluid with an automatic pen, and write a calligraphic letter. Avoid stringiness in the liquid by cleaning the pen frequently, and add a little water to improve the flow if necessary. Leave it to dry thoroughly. Meanwhile, clean your pens and brushes in warm soapy water to prevent the fluid from hardening and clogging the instruments.

5 Gently rub the masked areas with a finger to remove the rubbery fluid. This will reveal the underlying paper, and create a "reversed out" effect – white lettering on a colored ground.

7 When the fluid is completely dry, paint the whole area of the card with water.

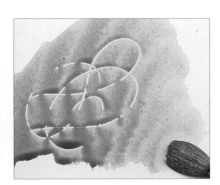

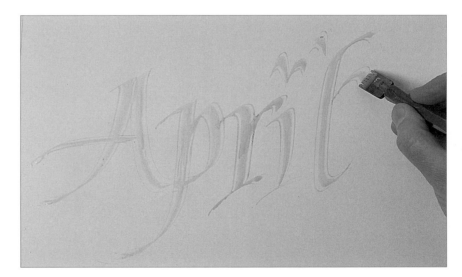

4 Mix some watercolor, apply a rough wash over the area, and watch the masked strokes emerge as they resist the paint. Leave the wash to dry.

6 Try building up a more complicated background around some lettering. Write a word in masking fluid on colored cardboard. Choose the color according to the word. Here, a springtime yellow is used.

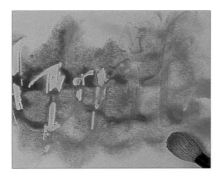

8 Load the brush with a strong mixture of blue watercolor and drop this into the wet areas. Adding color in this way causes the paint to flow with soft edges. You can also create light and dark patches at will by simply adding a touch more color. Notice how the blue looks green in places where it is applied thinly, because of the underlying yellow base.

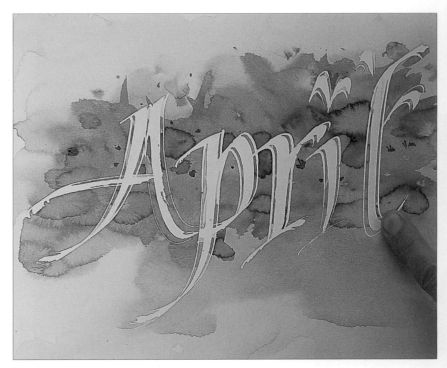

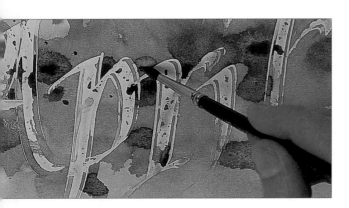

9 Before the color is entirely dry, dab on dots of red with a smaller brush. These spread in the wet, giving the impression of tiny spring flowers.

10 When the watercolor is thoroughly dry, remove the masking fluid by gently rubbing with a fingertip. The revealed lettering remains in pristine condition under the built up washes and the yellow coloring adds to the springtime effect.

Conventional pen

A conventional pen is used for the masking fluid. Red and yellow watercolors are then streaked across, some wet-on-dry, some wet-on-wet.

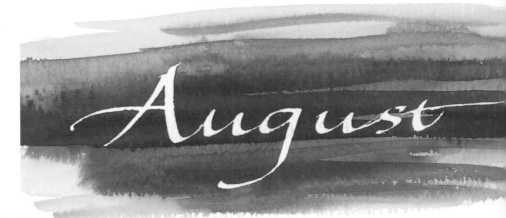

Automatic pen

The word is written with an automatic pen and then washed over with blue and purple. Note the granular effect of the blue.

Ruling pen

The word is written with masking fluid and a ruling pen, and then color washed over. The central streak is the wettest and the page is held upside down to make it run.

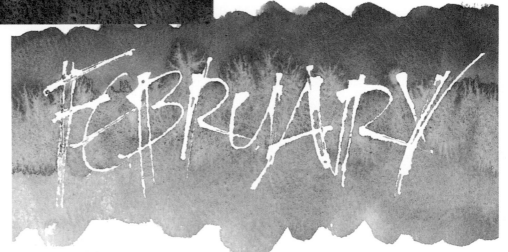

MATERIALS

Red and black ink

Layout paper

Red paper

Fiber-tip pen

Witch pen

Automatic pen

Pencil

Ruler

Eraser

Soft brush

Bleach

Water

Pipette

LETTERS THEMSELVES CAN PRODUCE AN INTERESTING BACKGROUND FOR OTHER LETTERING. USING A COLORED INK THAT CLOSELY MATCHES THE WRITING surface creates a subtle and rich effect. Used sparingly, a bleach solution can make chosen letters or words stand out. The difference in scale, choice of color, and use of mediums means that the background remains a unified texture, while the prominent lettering is clearly visible.

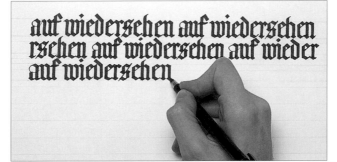

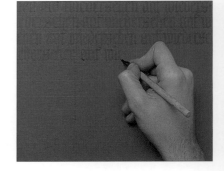

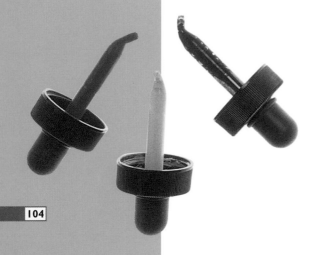

1 Practice writing the lettering on layout paper with a fiber-tip pen until the letter, word, and line spacing are correct. The words *auf wiedersehen* are repeated many times. By keeping the spacing even and fairly tight, a smooth texture is generated. Offset the wording on the second line, so that rivers do not run down through the block of lettering. Begin the third line in the same place as the first; the fourth as the second, and so on.

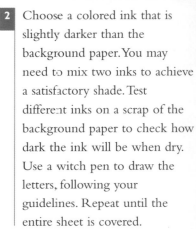

2 Choose a colored ink that is slightly darker than the background paper. You may need to mix two inks to achieve a satisfactory shade. Test different inks on a scrap of the background paper to check how dark the ink will be when dry. Use a witch pen to draw the letters, following your guidelines. Repeat until the entire sheet is covered.

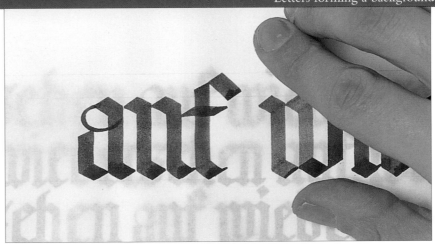

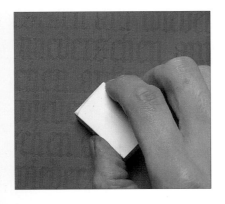

3 Wait until the lettering is thoroughly dry, and then erase the penciled guidelines.

4 Remove the eraser debris with a soft brush. Do not use your hands because grease left on the paper surface will affect the ink or paint coverage of the lettering you apply on top of the background.

5 The same words and letterstyles are used for the background and the main message – the only difference is the size of the lettering. Draw the larger letters of the main message on layout paper first. Place this over the original layout sheets for the background, so that you can see how they look together. You may have to try various sizes before finding the best solution. In this case, the height of the large letters is equal to two rows of the background lettering.

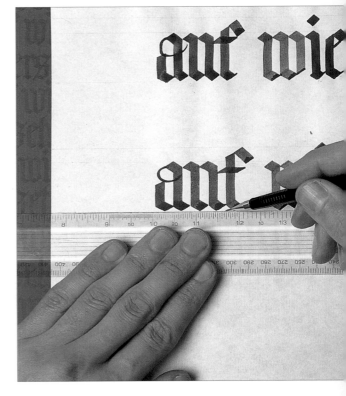

6 Using the layout sheet as a guide, transfer the letter heights onto the background, and rule guidelines in pencil.

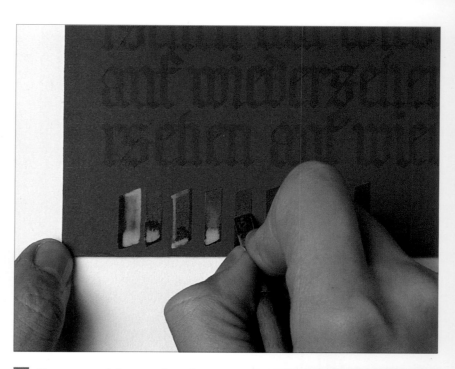

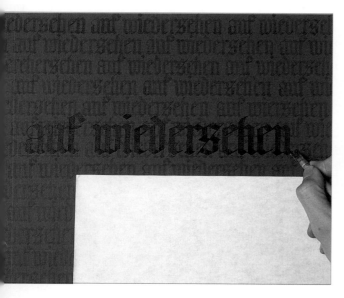

7 Draw the letters in black ink over the background. Protect the background with a clean piece of paper while you work. Next, mix a solution of 4 parts water to 1 part bleach. Stronger mixtures will achieve greater brightness, but the bleach will continue to affect the board and ink for months.

8 On a scrap of the same board, draw a series of vertical lines in black ink. When dry, draw over them with the bleach solution to test the effect. You may want to add more water. After a few minutes the bleach will remove some of the color from the ink and the board. It is worth carrying out this test on various colored boards. In some cases a lighter shade of the colored board appears; in others a totally different color is produced.

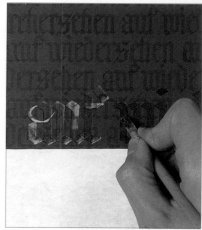

9 Here, the lettering with the bleach solution is slightly offset from the black ink, forming a thin drop shadow. This helps to create depth and lifts the words from the background.

Contrasts in scale

Blue writing on blue card makes a pleasantly subtle effect. The larger version of text in bleach stands out only by virtue of its size as its color is tonally similar to the background.

Tonal contrast

Here, the bleach is allowed to stand out from the background to create tonal contrast as well as contrast in scale.

Subtle effect

Here, we have a light blue-on-blue background, with an extremely subtle ink-and-bleach effect for the final lettering.

MATERIALS

Heavy- or medium-weight
watercolor paper (stretched)

Gouache

Automatic pens

Hand-held shower spray

Water

Dish

Sponge or paper towel

Hairdryer

Paintbrush

LETTERS TREATED AS REPEAT PATTERNS AND THEN WASHED OFF CAN CREATE AN ATMOSPHERIC BACKGROUND OF FADED IMAGES AND varying tones of color so that the words appear to recede far into the distance. The writing and washing off can be repeated as many times as necessary to build up the desired effect.

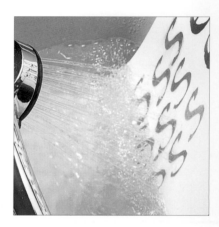

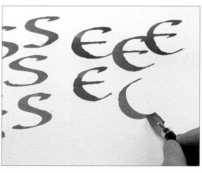

1 Experiment with some letters to become familiar with the reactions between the paper and the gouache. Sometimes the paint sinks into the surface, or stains, and does not wash out much; on other papers, most of it will wash away. Pigments can behave differently also.

2 When the writing is dry, rinse the entire sheet with a hand-held shower spray and see how much color washes away; stop quickly if it is fading too much. Mop up the excess water with a sponge or paper towel and leave the paper to dry naturally, or use a hairdryer.

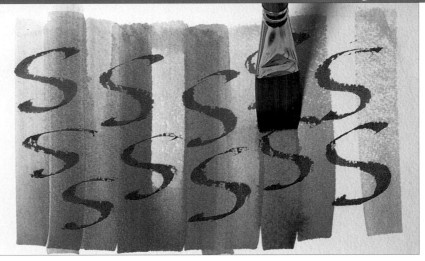

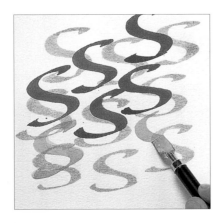

3 Write another layer of letters on top; if you use the same paint, you can see just how much or how little the first layer has washed off. Try using a different color also.

5 Do a trial experiment with the same brush, applying a thin wash of color in stripes over the letters. This will soften them and blend them into a more unified background effect.

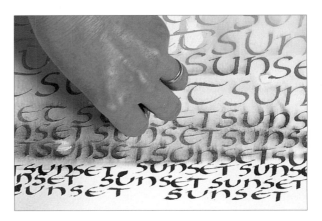

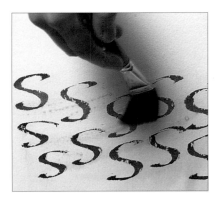

4 If insufficient color is removed by spraying, you can continue rubbing it off with a wet brush.

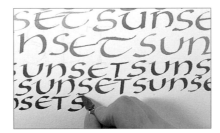

6 Now for a more complex experiment. Write freely across the entire page, repeating a single word. Change the color with each line, from yellow to orange, red, blue, and purple. Use different-sized pens to vary the writing size and weight; this will add interesting calligraphic textures to the design. Leave it to dry completely.

7 This time, we want more control over the washing off so that more color is retained. With a damp sponge, carefully remove some of the paint and smudge it across the page. Here, a sideways movement produces soft sweeps of color to convey the atmospheric effect of a sunset.

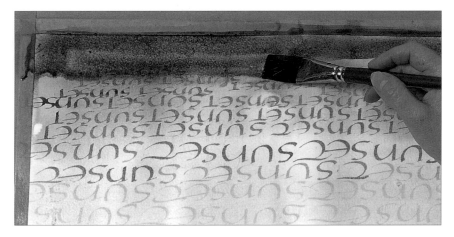

8 Turn the paper upside down and place it on a sloping surface. Mix some purple paint, and apply it form the top, allowing it to merge into the red to obtain a graduated effect.

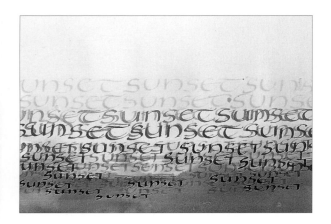

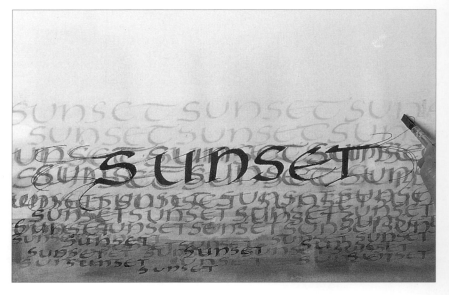

9 When dry, write again with more color over the faded original, making additional pattern and texture with the repeated words. Leave to dry (or use the hairdryer).

10 Sponge again, but very lightly this time, removing just a trace of color. When completely dry, write the final word of the composition on top – in gouache again, or acrylic ink.

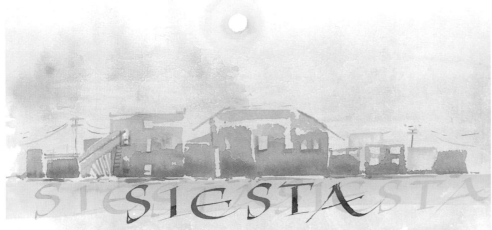

Painted shapes

Background shapes are loosely suggested on top of the base wash using a brush. Lettering is added, then washed off, to create an atmospheric piece.

Multimedia

Several layers of acrylic ink and gouache are applied and then washed off to create this texturally intriguing and colorful night sky.

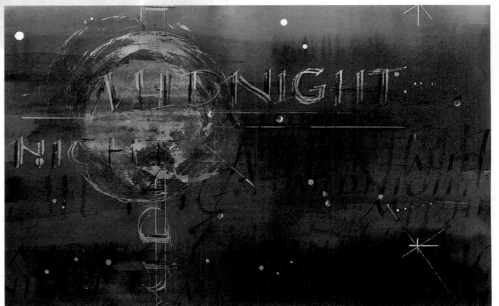

Masking tape

Masking tape and fluid are used to establish the horizon line before successive layers of washes, lettering and washing off complete the piece.

111

MATERIALS

Acrylics or watercolors
Line-and-wash board
Layout paper
Black fiber-tip pen
Paintbrushes
Pencil
Ruler
Eraser
Palette and mixing bowls
Masking tape
Dividers

THIS TECHNIQUE PRODUCES A MULTICOLORED ALPHABET AND BACKGROUND THAT HAVE THE SAME visual impact – the backing colors are just as strong and applied in the same way as the letters. Choose a letter style which has similar sized strokes, counters and bowls to emphasize this even further.

1 Design the letters in pencil on layout paper. Here, a stylized, geometric blackletter style was chosen because it has large flat areas. In addition, the counters and bowls of these letters are similar in size to the letter strokes – this is an advantage when seeking to give the background and the letters equal visual importance. When you are satisfied with the letter shapes, draw them with a black fiber-tip pen. This will allow you to see them through another sheet of layout paper.

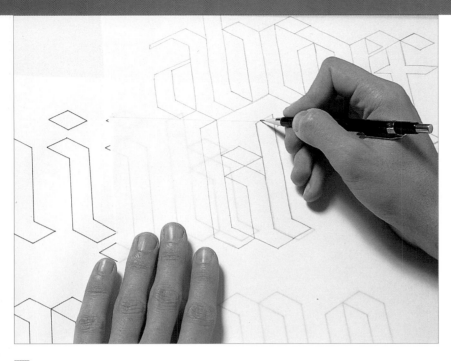

2 Design the composition, also on layout paper. Move the paper around over the letters and draw the outlines with a pencil.

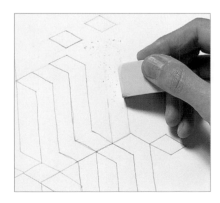

3 Using pencil enables you to make any necessary corrections and amendments easily.

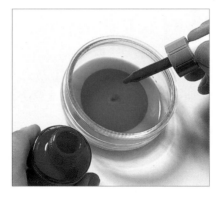

4 Soft pale colors are needed, so add a small amount of acrylic or watercolor to some water in a mixing bowl, and stir gently with a paintbrush.

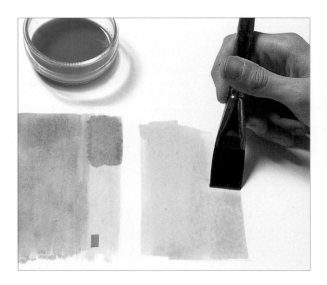

5 Test the color on a spare piece of the board to be used for the background. Add more water or color as necessary to achieve the desired strength.

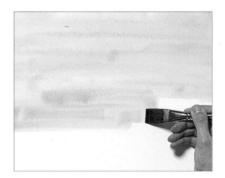

6 When you are happy with the color, lay a wash over the entire board with a large paintbrush. This should be done quickly with horizontal brushstrokes, each stroke overlapping the previous one as you work gradually down the board.

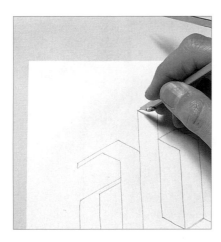

7 When the wash is completely dry, place the layout paper with the design on the board and attach it with masking tape. To transfer the letters, use a pair of dividers to make a small point at each corner. Alternatively, you can trace the letters onto the board with a pencil.

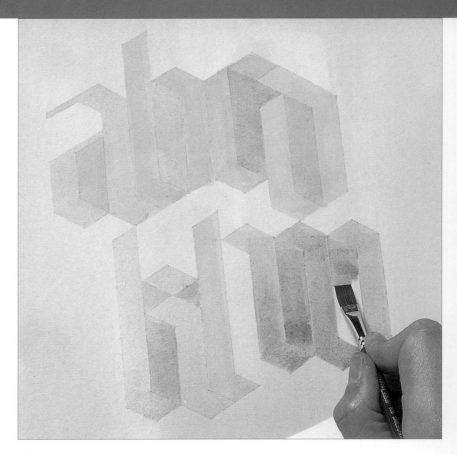

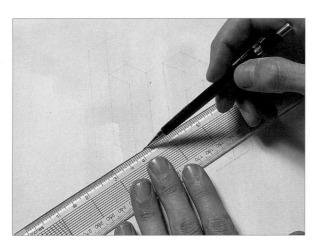

8 Join all of the points with faint pencil lines so that they will not show through the pastel colors.

9 Using a small or medium flat paintbrush, apply different colors to the letters, one at a time. Try to mix the water and paint to the same tone as that used for the background. Protect the background with a sheet of plain paper as you work. Gradually build up the alphabet using different colors, filling the counters, bowls, and shapes in and around the letters at the same time. When colors need to touch each other, allow the first to dry before adding the second – otherwise they will bleed into each other.

Monochrome effect

Darker reds on a red background highlight the geometric qualities of the black letter and produce a warm and subtle effect.

3–D effect

The gray-blue inks painted in or between the letter shapes give an overall three-dimensional quality to the design.

Soft and subtle

The brown and beige color scheme used here also has a three-dimensional effect but is even softer and subtler than the others.

115

MATERIALS

Heavyweight watercolor
paper
Narrow masking tape
Sponge brush
Gouache
Paintbrush
Shower spray and water
Waterproof inks
Ruling pen
Automatic pen
Metal pens

THIS COMBINATION OF TECHNIQUES
USES COLORED BACKGROUNDS, MASKING
TAPE, WASHING OFF, AND DRAGGING COLOR
WITH A SPONGE BRUSH AS WELL AS MANY
different lettering pens, exploiting the properties of
both waterproof inks and gouache paints. Effects can be developed,
repeated, and adapted as you proceed, creating striking and unique results.

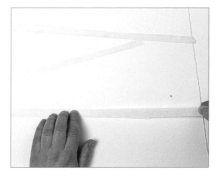

1 Use strong paper, which can
withstand heavy treatment.
Position the masking tape on
the sheet of paper, sticking it
down at various angles.

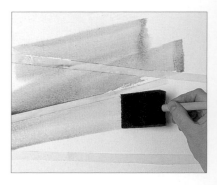

2 Load a large sponge brush with
paint and apply bold stripes of
colored gouache across the
paper. This kind of brush holds
a lot of liquid, so large areas can
be covered rapidly. Leave to dry.

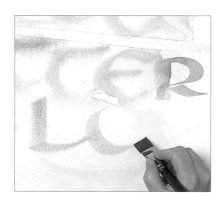

3 Now take a wide chisel-length brush, loaded with paint, and use it like a pen to write bold letters across the page. When it is dry, put the work under a shower spray and rinse it until the lettering pales and blends into the background.

5 Add more letters, writing them with an automatic pen holding much darker ink. While the ink is still wet, drag the lettering across the page with a wet sponge brush. You can continue repeating any of these techniques, reacting to what you create at each stage.

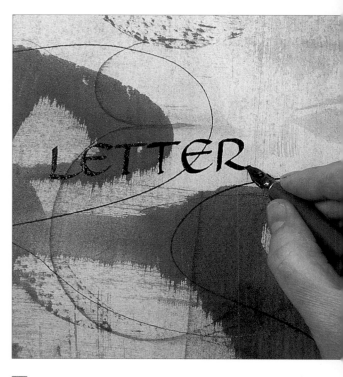

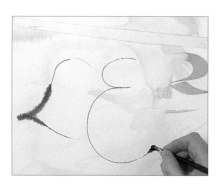

4 Before the paper is fully dry, write some letters with waterproof ink in a ruling pen. Watch how it spreads to give another interesting feature.

6 Try using the ruling pen again, this time on dry paint. If you are not familiar with this tool, practice on some scrap paper first to find the best grip to give free, uninhibited strokes.

7 Position some smaller lettering at various angles over the page, using a conventional metal dip pen and black waterproof ink.

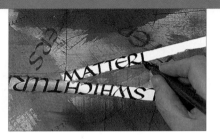

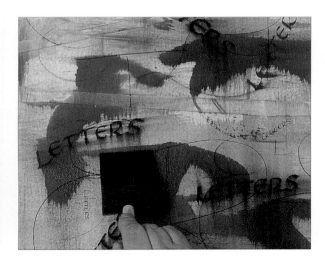

10 Write some words in capitals in the areas revealed by the removal of the masking tape.

8 Drag the sponge brush across a few more times to achieve an even texture of layers. Leave the work to dry completely.

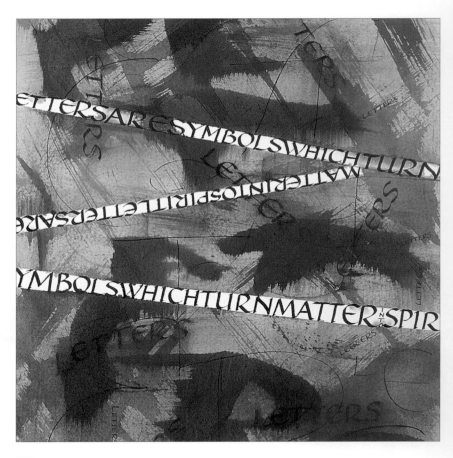

9 Peel away the masking tape carefully to prevent it from lifting too much of the paper's surface. Rub the exposed surface with the flat part of a fingernail to smooth it ready for writing.

11 The final piece is an unusual and striking piece of work, combining many of the techniques described individually in this book.

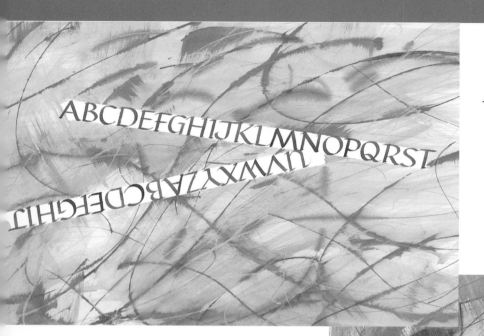

◄ **Green and yellow**
The pearlescent inks are applied with a sponge brush and ruling pen. This combination of colors has a light, fresh appeal.

Bright multicolors ►
Magenta, yellow, green and pink pearlescent inks produce a sparkling and lively composition.

◄ **Black and red**
The techniques and equipment used remain the same but, with a simple change of color, the effect is more dramatic.

BORDERS

AND IMAGES

HERE ARE MANY WAYS TO ENHANCE YOUR WORK BY FRAMING IT WITH SOME FORM OF DECORATIVE BORDER. SOME OF THE IDEAS THAT FOLLOW SHOULD START YOU off: simple pen patterns, repeat patterns using homemade stencils, multiple letters. Whole images can also be created, making a word picture or calligram, which is fun to try and does not require great drawing skills.

MATERIALS

Ruler
Pencil
Layout paper
Metal pens
Automatic pens
Watercolors or gouache
Palette
Heavyweight drawing
paper
Paintbrush
Nonwaterproof black and
blue inks
Old piano key
Ink dropper
Paintbrush
Bleach
Bulldog clip

A GOOD WAY TO INCORPORATE A
BORDER WITH CALLIGRAPHY IS TO
PRODUCE BOTH WITH THE SAME
WRITING IMPLEMENT, ALTHOUGH THE
BORDER MAY NEED TO BE MADE WITH A
smaller version to avoid overwhelming the text. Simple
repetitive marks, perhaps using more than one color, can create a
pleasing decorative border. More dramatic effects can be produced by
"reversing out" the border from a dark background, by using bleach, for example.

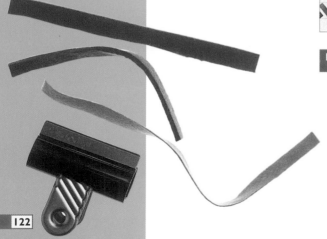

1 Rule some guidelines with a
pencil. Experiment by drawing
different marks repeatedly with
metal and automatic pens, using
watercolor or gouache. These
patterns are achieved by holding
the pen at a constant angle and
maintaining a regular size and
consistent density of paint.

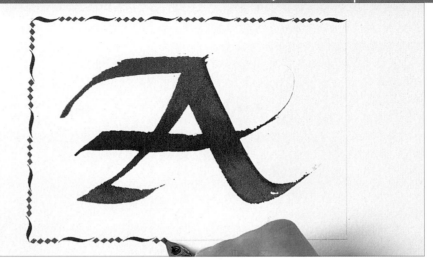

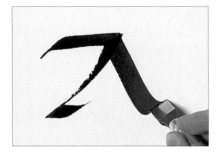

2 Always complete the lettering before attempting the border, which can be adjusted to fit. Here a single letter is written in gouache with an automatic pen.

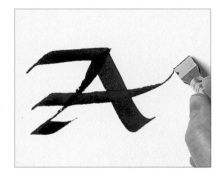

3 Create color change within the letter by feeding a second color into the pen's reservoir with a paintbrush after the second stroke, and progressing with alternate colors until the letter is completed. You can then use the two colors in the border.

4 Draw a faint guideline in pencil around the letter where the border will be. When the border consists of different shapes and colors like this one, mark the change points along the guidelines to keep the pattern consistent. Use a separate pen for each color.

5 After some practice designing borders you may want to try some more unusual techniques for producing them. Apply nonwaterproof ink to an old felt piano key, using a dropper or a paintbrush.

6 Make a textured background by drawing parallel strokes vertically then horizontally across the paper, recharging the pen frequently with ink.

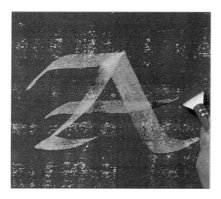

7 Mix a solution of 1 part bleach to 4 parts water in a small container. When the ink background is dry, fill a large automatic pen with the bleach solution and write the letter.

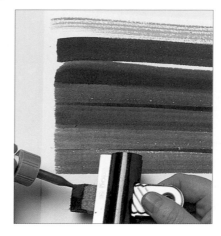

9 A multicolored background can be made easily by applying two colors to the felt key simultaneously. Hold it with a large bulldog clip if you find that easier, or use a wide automatic pen or a wide flat brush. Paint vertical and horizontal lines of texture as before, using nonwaterproof ink. Here, most of the piano key holds black ink but a small amount of blue is added at one end. The touches of blue add sparkle to the dark background.

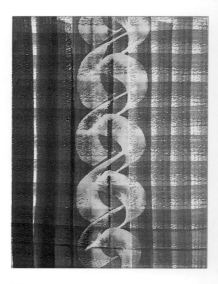

10 An intertwining pattern, drawn in bleach solution with a large automatic pen, allows some of the background lines to show through. The pattern is positioned centrally for a more unusual composition. Combined with the widely spaced stripes, this creates a "busy" background that would need to be matched by a bold piece of calligraphy.

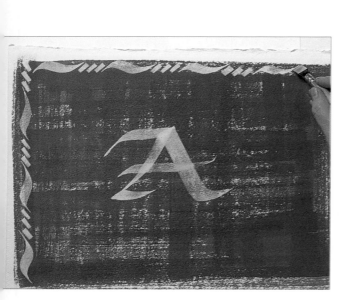

8 Complete the design by drawing the repetitive marks around the edges of the background in bleach solution.

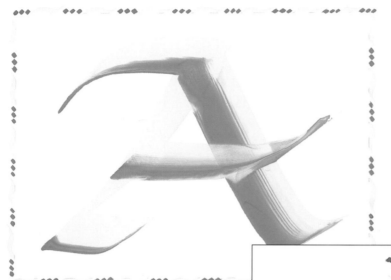

Single border

The yellow and green ink used in the central letter are repeated in the border to unify the design.

Double border

Red and yellow are used alternately in the border to match the colors in the letter. The border is the same width as the stem of the letter to keep in scale.

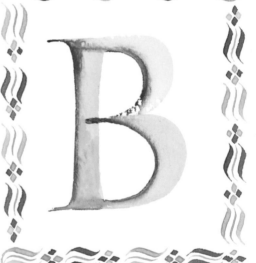

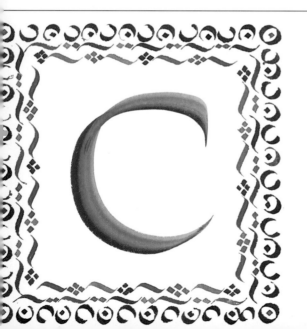

Triple border

The three colors of the letter simulate part of a rainbow. The colors are developed into a complex combination of simple marks for the border.

MATERIALS

Layout paper

Automatic pen

Metal pens

Inks

Pencil

Metal ruler

Drawing paper

Colored cardboard

Gouache

Bleach (optional)

Craft knife

LETTERS, OR REPEATED SINGLE WORDS OR PHRASES, CAN BE USED TO FORM UNUSUAL BORDERS THAT FURTHER ENHANCE A PIECE OF CALLIGRAPHY. THIS IS A DEVELOPMENT from repetitive mark-making, such as pen patterns. The borders can be as modest or complex as the context demands, but they often look best in their simplest forms, made with a small pen to contrast in size with the calligraphy or pictorial design they are framing.

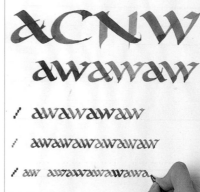

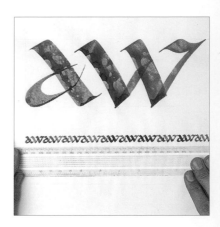

1 Select a style of lettering for the border that reflects the one used for the main piece of calligraphy. Here, Uncials were chosen, because their heavy structure and even height produce a visually consistent line. Do some trials on layout paper, from large automatic to small metal pens.

2 Choose a good contrast of size between the border and main lettering, and write them together to check your decision. Measure the length of a "repeat" in the border pattern to help you gauge the line lengths – particularly important if you are using words or phrases.

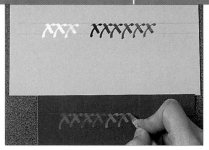

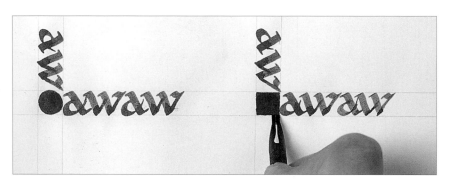

3 Before you do the final piece, you need to decide how you will treat the corners. A decorative shape, such as a simple square or circle, could fill them neatly.

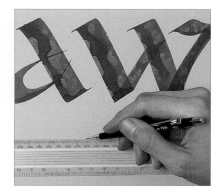

4 Draw the main lettering on your chosen paper or cardboard. When it is dry, measure around it and rule light guidelines for the border, remembering to allow for the length of your "repeats."

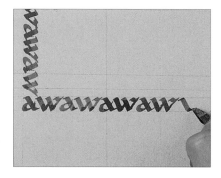

5 Select an ink color – in this case, red for contrast – and write the border carefully between the guidelines. Try to make the letter spacing constant throughout. Here, the corner was resolved by starting the new line immediately at right angles. This is successful because there are no ascenders or descenders to disturb the top line.

6 As an alternative to putting the border immediately around a piece of work, you can apply it to a separate cardboard or paper mat. This gives you the opportunity to frame the work in a contrasting color as well as adding a border decoration. Some letters, such as X, are so decorative in their own right that they can form border motifs which are no longer seen as letters. Try several color arrangements, using gouache and bleach, for example.

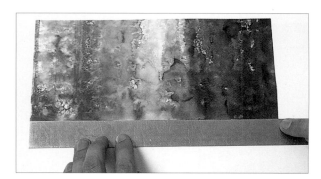

7 Complete your calligraphy or pictorial design, and trim the edges to square it up. Then make measurements to determine the size of opening needed for the mat.

8 Transfer the measurements as guidelines on the back of the mat. Cut the opening from the back, using a craft knife and a metal ruler (the knife could damage a plastic or wooden one). Remove the center.

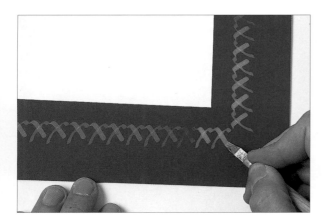

9 Measure and rule guidelines lightly on the front of the mat, and carefully apply the repeat letter design in your chosen color. Here a bleach solution was used, but gouache would be a suitable alternative.

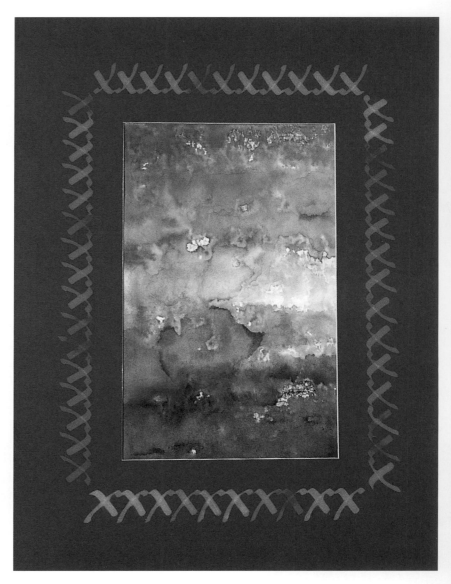

10 The subtlety of the image is complemented by the soft treatment of the border pattern.

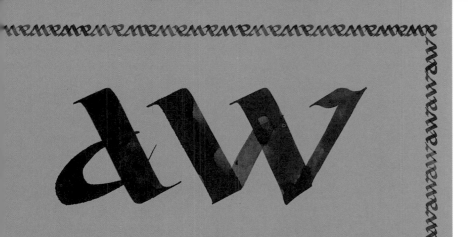

Altered colors

Blue ink becomes green on this yellow/brown paper and the semi-transparent purple border appears neutral.

Analogous colors

A green border blends with the pastel green background and analogous blue is chosen for the central image.

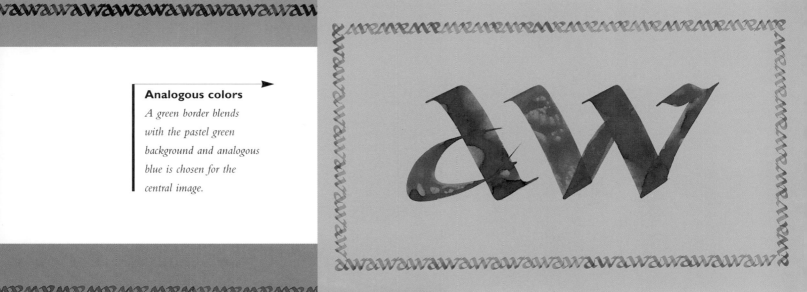

Subtle watermarks

Blues on blue/gray makes a subtle combination. Note the watermark effects achieved as a result of puddling the ink.

MATERIALS

Ink block

Pastel or conté crayons

Paper

Ruling pen

Pencil

Eraser

Ruler

Craft knife

Cardboard

Masking tape

Toothbrush

BORDERS TEND TO BE MADE UP OF REPETITIVE MARKS BUT THIS SHOULD NOT MEAN THAT THEY ARE UNCREATIVE. RUBBER STAMPS AND STENCILS ARE IDEAL FOR producing borders, because the image remains constant however often you repeat it. Simple shapes, such as leaves or stars, often work better than detailed images but you must have a steady hand to prevent smudging.

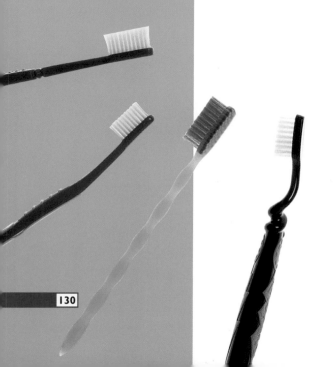

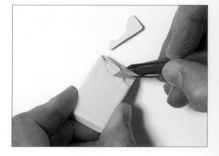

2 Carefully cut around the leaf shape. Remove pieces of the eraser from around the edges, leaving the leaf standing out. This forms the rubber stamp.

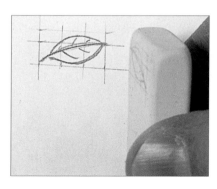

Rubber stamps

1 Begin by sketching the image. Keep the shape simple, like this leaf. Transfer or redraw the image onto an eraser.

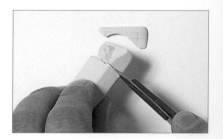

3 Cut part of the eraser away, so that you have a comfortably sized piece to print with.

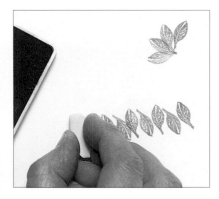

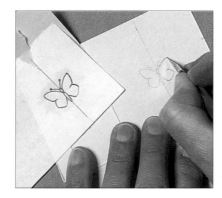

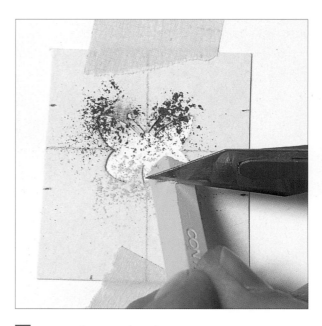

4 Practice using the rubber stamp on some scrap paper. Press the stamp onto an ink block and then print. To prevent smudges, bring the stamp away vertically from the paper surface. Instead of using an ink block, you can put inks onto the rubber stamp with a paintbrush. Try different patterns and combinations of your images. Use light and dark colors to build up a border.

Stenciled images

1 Draw the outline of a butterfly shape in pencil on layout paper. Draw a line through the center of the butterfly. This will help you to position the stencil at the correct angle. Transfer the finished image to a piece of cardboard, and cut it out carefully with a craft knife.

2 Secure the stencil to the writing surface with masking tape. Gently scrape a craft knife over a piece of pastel or conté crayon to release powdered color into the open part of the stencil. Try mixing two colors, one at the top and one at the bottom of the stencil shape.

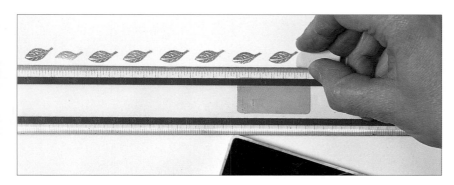

5 Rule lines in pencil or use a ruler to guide you when printing the border. The ruler will also enable you to measure the exact gap between prints.

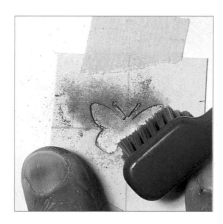

3 Brush the powder into the writing surface by rubbing an old toothbrush softly over the cutout shape. Take care not to spread any of the color beyond the outside edges of the stencil.

Combining stamps and stencils

1 Mark out the area of the border by using a ruling pen to draw thin black lines around the outside. Place the ruler upside down (i.e. with the edge off the writing surface) to prevent ink from seeping underneath it.

2 Position the butterfly stencil over each corner in turn, and apply the color as before.

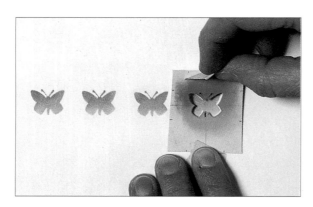

4 Carefully remove the masking tape and peel the stencil off the writing surface. Repeat this process at regular intervals to form a border. Use a ruler to keep the line of images straight.

3 Use the rubber stamp to print leaves between the ruled lines. Here, two parallel lines of leaves in different shades are printed, forming a regular pattern within the ink rules. The finished border can be cut out to use as a frame, or to provide an edging for a piece of calligraphy.

Analogous colors

Red and brown on orange makes an analogous color scheme. The leaf border and corner butterflies are effective even though they use the same colors.

Change of direction

Sufficient interest is given to this green on neutral cream border by arranging the leaf prints to point in different directions.

Change of intensity

The regimented lines of butterflies are softened by the change at the corners, and the variations in the intensity of the colors.

MATERIALS

Ruler
Pencil
Layout paper
Tracing paper
Drawing paper
Gouache or watercolors
Metal pens
Brown waterproof ink
Paintbrushes

PICTURES MADE WITH LETTERS ARE FUN TO DO IF YOU HAVE A LITTLE IMAGINATION. CREATE AN IMAGE BY WRITING WORDS IN A SHAPE that represents their meaning – known as a calligram. Alternatively, some words lend themselves to illustration by incorporating a picture within one of the letters. The images can be rendered very simply and therefore do not require great drawing skills.

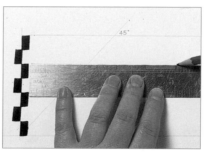

1 Rule lines at the appropriate measurement for your chosen pen: here at 5 nibwidths for the lowercase, and 7 for the capital. Write the word – in this case, *Adam*. When it is dry, trace the outline of the letters and transfer them onto the drawing paper.

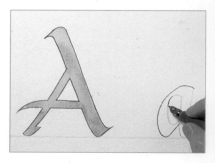

2 Take a narrow-nibbed pen loaded with brown waterproof ink, such as acrylic. This will not smudge when the letters are painted. Carefully redraw the outline of the letter *A*. When the outlined letter is dry, fill the letter with yellow, and then add some red while the yellow is still wet to create a mottled, two-tone effect. When it is dry, draw the outline of the rest of the letters, but leave out the *d,* which will be merged with a simple image of a tree.

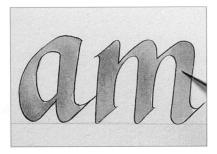

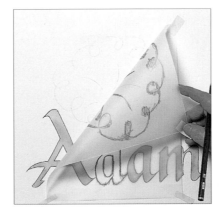

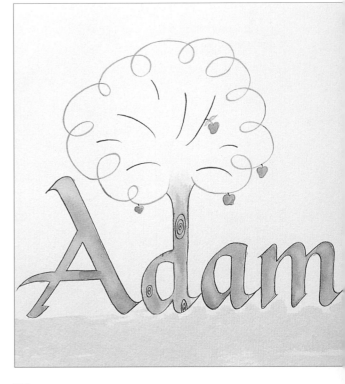

3 Color the rest of the letters in the same way as the *A*. By completing the *A* first, you avoid any possibility of smudging the rest of the letters. However, you must mix enough paint for all of the letters at the same time so that you get a perfect color match.

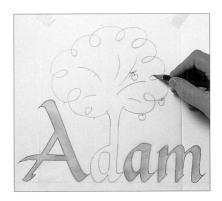

4 Place a piece of tracing paper over the word and sketch in the tree growing from the *d*. You can keep erasing and redrawing until you are satisfied. Remove the tracing paper, turn it over, and scribble over the lines with pencil.

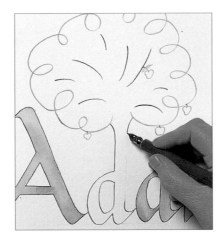

5 Replace the tracing paper in position, and draw over the lines to transfer the image to the paper. Lift the tracing to check that it is working; if it is not, press harder.

6 Draw the outline of the tree with the narrow–nibbed pen. Then paint the *d* in the same way as the other letters.

7 Leave the tree uncolored, but paint in the apples delicately. Add a pale wash of color underneath the word to imitate the ground beneath the tree.

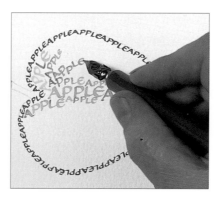

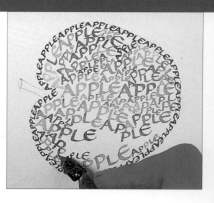

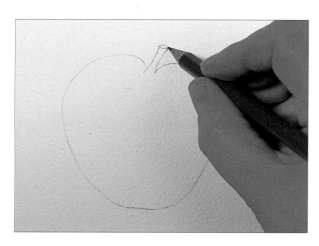

8 Use the idea of an apple again, this time for a calligram. Draw a larger apple shape in pencil.

10 Change color, and write the word again many times inside the apple shape, in different sizes but closely spaced.

11 Keep writing to fill the space completely, using toning colors and arranging the letter sizes and colors to suggest the form and markings of a real apple.

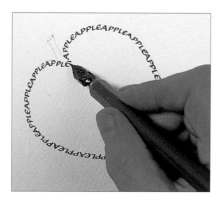

9 Write the word *apple* repeatedly, without gaps, all around the outline using gouache or watercolor. Turn the paper as you travel around, spacing the letters to achieve a neat join.

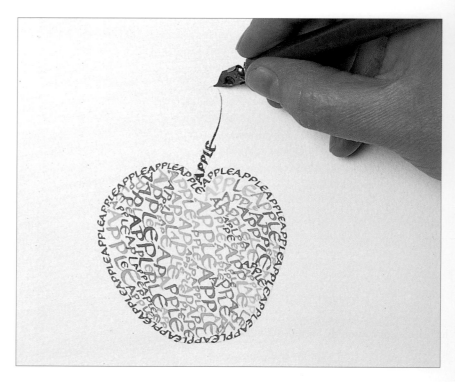

12 The final touch is the brown stalk, with an added flourish to complete the illusion.

Pearlescent ink

The word is outlined in magenta and infilled with magenta and yellow pearlescent inks.

Ink and gouache

The design is outlined in brown waterproof ink and colored with gold gouache.

Ink and watercolor

Green waterproof ink outlining is filled with green and tangerine watercolors. Note the mixing that occurs.

MATERIALS

Selection of leaves

Paper

Pencil or fiber-tip pen

Thin cardboard

Craft knife

Cutting mat

Colored paper

Watercolors or inks

Palette

Automatic pen

Flat paintbrush

Paper towel

BORDERS DO NOT HAVE TO BE RECTANGULAR OR CONSIST PURELY OF STRAIGHT LINES AND RULES. ILLUSTRATIONS RELATING TO THE SUBJECT

matter of the wording can bring a piece of calligraphy to life. Here, leaf shapes are stenciled around the Latin name for the particular leaf used. This would be suitable for many types of plants and flowers.

I Choose a selection of suitable leaves, and draw their shapes on a sheet of paper with a pencil or fiber-tip pen. When satisfied with your image, transfer it onto a piece of thin cardboard.

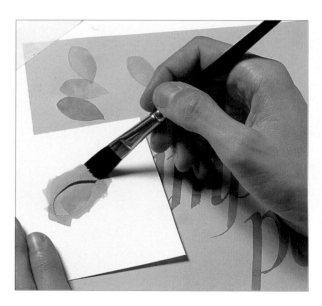

2 If you are not confident about your drawing skills, trace around the actual leaf.

3 Using a craft knife with a sharp, pointed blade, carefully cut out the leaf shape. Prepare two or three stencils in this way.

4 Draw your previously designed lettering on a piece of colored paper or cardboard, with an automatic pen and ink.

5 While the lettering is drying, experiment stenciling the leaf shape on a scrap piece of paper in pale watercolor or ink mixed with water. Try overlapping with different strengths of color. After each stencil, dab the color with paper towel. This means that the leaf shapes dry instantly and do not blend into one another when overlapped.

6 Begin to apply the leaf shapes at random angles around the edges of the background.

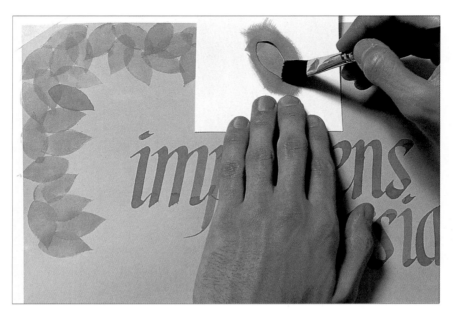

Printing with leaves

An alternative method is to print from the leaf itself. This requires a good supply of suitable leaves and the result will depend upon their type and strength – test them to see if they will stand up to the process. Carefully press the front of the leaf onto a soaked inkblock. Then transfer the leaf onto a sheet of paper and press evenly. Some leaves will create an imprint of their surface texture.

7 Using different strengths of color, and mixing colors if you wish, work around the lettering.

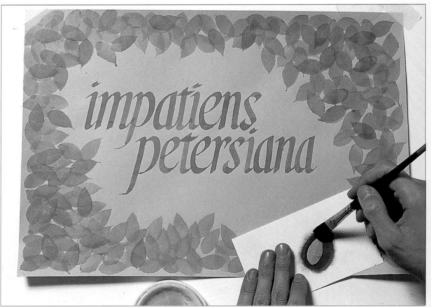

8 Allow the shape of the lettering to dictate the shape, width and density of the border.

HOWEA
forsteriana

Cotton wool

Cotton wool is dipped into green and yellow paint and pressed through shapes cut from acetate to enhance the lettering.

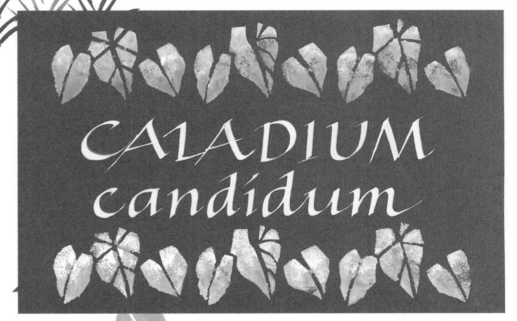

CALADIUM
candidum

Sponged colors

The border is applied with a sponge dipped in white, yellow and green paint, and then rubbed through an acetate stencil.

FISCUS
robusta

Streaks of ink

The streaks created by wiping ink across the stencil with cotton wool add a sense of immediacy to an attractive design.

MATERIALS

Selection of watercolor/
handmade/drawing papers
Watercolors or gouache
Paintbrushes
Ruler
Metal pens
Paper glue

EMPHASIZING THE EDGES OF THE PAPER WITH PAINT CAN RESULT IN ATTRACTIVE AND UNUSUAL BORDERS. YOU CAN PAINT DIRECTLY ONTO STRAIGHT EDGES, OR USE HANDMADE paper which has an uneven outline. An interesting technique is to tear machine-made paper to imitate the ragged edges of handmade paper, and then accentuate them with color. You can layer one piece on top of another to emphasize the border effect.

1 To create a rough edge, mark lightly in pencil against a ruler on the reverse of the paper. Paint the line against the ruler with a paintbrush of water; make sure that the brush and water are clean so that you do not stain the paper.

2 When the water has soaked in (it will need longer if the paper is thick or heavily sized), carefully tear the paper against the ruler, pulling gently outward to tease out the fibers and make a ragged edge.

3 Do the same for all four sides to make the shape you want. Mix some paint and load a large brush. Lightly touch the edges of the paper with the paint, controlling the amount so that all edges are evenly covered.

4 Try different colors and papers. Wet paper will absorb the paint more evenly than dry. Paint it while it is still wet from tearing, or re-wet the edges before painting to check the effect.

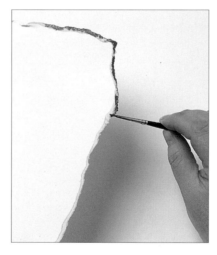

5 Experiment with a multicolored border. Outline all of the edges with your palest color, then overpaint with other shades. Again, if the first color is wet the additional colors will blend more than if you allow it to dry.

6 For a more complex, layered border, prepare several papers in descending sizes, and paint their edges in coordinated colors.

7 When the paint is dry, glue the papers one on top of the other. Make sure that they are centrally and evenly positioned.

8 The final, central piece would be the paper bearing the calligraphy. This way, you can prepare calligraphy and borders separately, and select the best results to put together.

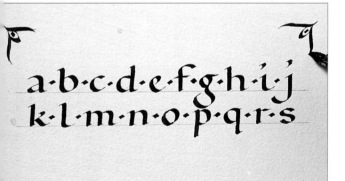

9 A strongly colored border demands bold calligraphy. Experiment with the samples you have torn and painted to determine what kind of calligraphy would be compatible with this technique.

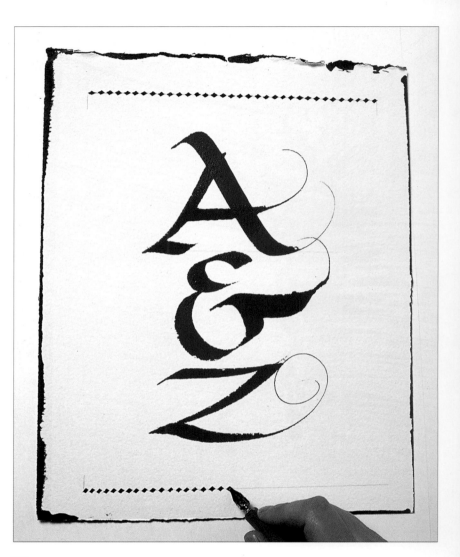

10 Dramatic letters in a vivid color need plenty of margin, and are best set off by a narrow border of contrasting color, along with minimal decorative detail.

Multicolored layers

*Three layers, using white
and yellow paper, produce
a bright border which
effectively enhances the
central red image.*

Border devices

*Only two layers of paper
are used here but with the
addition of some decorated
letters as an extra
border embellishment.*

Single color layers

*All three layers are made
from white paper but
variants of green are used
to enhance their torn
edges effectively.*

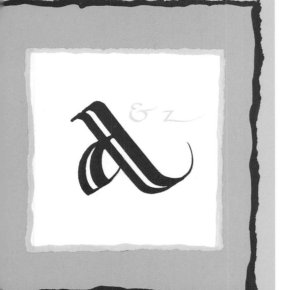

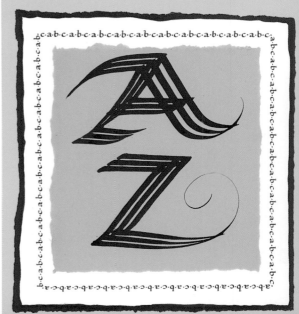

GILDING

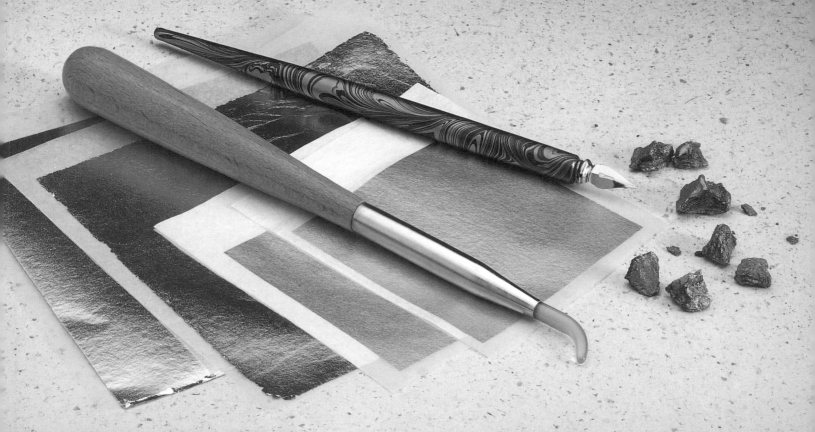

ANY MEDIEVAL MANUSCRIPTS CONTAIN ILLUMINATED PAGES, SPARKLING WITH RAISED GOLD. GILDING HAS REMAINED A POPULAR WAY OF ADDING A FLASH OF LIGHT IN modern calligraphy, and many experiments can be tried using both traditional and modern methods, using real gold leaf which can be burnished to a wonderful shine. You will find that even a tiny amount of gold can make a big difference to a piece of work.

MATERIALS

Distilled water

Shell gold

Small paintbrush

Small palette or bowl

Automatic pen

Paper or vellum

Burnisher

Gouache

Pencil

Ruler

SHELL GOLD IS AVAILABLE LOOSE IN TABLET FORM, AND ALTHOUGH IT GIVES A LESS SHINY SURFACE THAN GOLD LEAF, YOU CAN APPLY IT MORE EASILY USING A PEN

or brush. Since it is fairly expensive, be sure to plan your lettering and composition carefully first, using ink or a fiber-tip pen on layout paper. Shell gold also makes a striking background for colored letters.

1 Add a few drops of distilled water to the shell gold. Using a small paintbrush, mix to a consistency that will run smoothly from the pen. If the solution is too dilute, your lettering will not be opaque. Load the shell gold solution into the pen with the paintbrush.

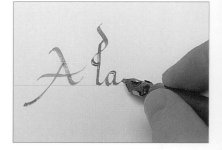

2 Referring to your layout sheets, draw the lettering. Regularly mix the gold solution before refilling the pen. When the lettering is complete, leave flat to dry for at least an hour.

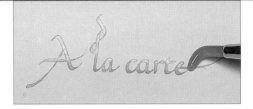

3 Shell gold dries fairly dull, and therefore the lettering will need to be burnished. The best results are achieved with an agate or hematite burnisher.

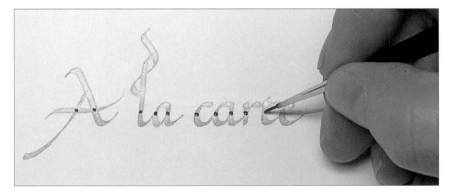

4 Decorate lettering drawn in shell gold with bright colors by painting gouache on top. Here, tiny highlights in red are added.

2 Plan out the composition, ruling the lines with pencil, and then paint the square of gold. Leave the area for the letter clear.

Shell gold as a background

1 Alternatively, use shell gold to create a background. Experiment with different colors next to a small patch of gold. Strong reds, greens and blues make a striking impact.

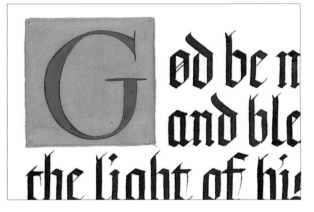

3 A colored dropped capital in a gold square at the start of a paragraph will contrast well with the text and draw the eye to the beginning of the passage.

MATERIALS

Gesso
Small palette or dish
Distilled water
Pipette
Fine paintbrush
Paper or vellum
Masking tape
Sheet of glass
Transfer paper
Pencil
Excise knife
Burnisher
Transfer gold
Loose-leaf double gold
Scissors
Soft brush
Gouache

CONSIDERED USE OF GOLD LEAF WITHIN A PIECE OF LETTERING CATCHES THE EYE AND CREATES A RICH DECORATION. GOLD LEAF IS OFTEN MORE EFFECTIVE IF USED SPARINGLY TO SURPRISE and excite the viewer. Gesso provides a surface to which gold leaf adheres well, producing a bright, almost mirror-like decoration. When dry, it is relatively flexible, so that it will bend with the paper or vellum. Gilding on gesso needs practice in order to achieve a good level of skill.

INGREDIENTS

3 parts fine powdered white lead (take great care not to breathe this in as it is toxic)
8 parts slaked plaster
1 part raw brown cane sugar
1 part fish glue (seccotine)
A small amount of red gouache
Distilled water
Pestle and mortar
Mixing bowl
Palette knife
Foil

Preparing gesso for use

1　Crush the sugar into a fine powder with a pestle and mortar, and then empty the sugar into another container.

2　Place the glue in the mortar, and add the plaster, white lead, sugar, and gouache. Pour in sufficient distilled water and mix to a thick paste with a palette knife. Grind the paste with the pestle until it is fine and smooth, adding more distilled water if necessary.

3　Using a palette knife, make small cakes of the mixture on a non-stick flexible surface such as foil. Leave the cakes to dry in a dust-free environment. When partly dry, score the surface of each cake so that pieces can be easily broken off when needed.

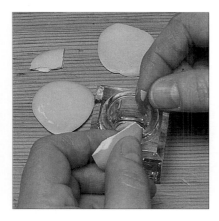

4 Break the gesso into tiny pieces and place in a clean palette or small dish. Do not prepare a large amount – just sufficient for one project at a time.

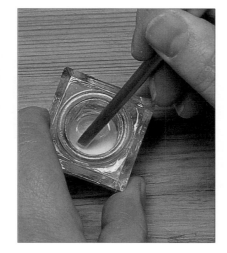

6 Gently mix the gesso into a paste. You can use the wrong end of a paintbrush to do this.

5 Add a few drops of distilled water to the gesso with a pipette and allow it to soak.

7 Add more distilled water to the mixture if necessary to achieve a smooth, fairly thin consistency.

8 It is important to lay the gesso evenly. Before applying it with a fine paintbrush, dip the brush in distilled water and squeeze the hairs to avoid bubbles. If bubbles persist, you can remove them by adding a drop of oil of cloves.

Applying gesso

1 Secure the vellum/paper to a
flat surface with masking tape.
Glass is the best surface. Fix a
square of transfer paper and
your previously drawn letter
into position with more tape,
and outline the letter with a
pencil to transfer it.

3 Leave the letter to dry overnight
in a dust-free environment.
Once dry, carefully peel off the
masking tape and transfer paper
to reveal the letter.

2 Using a fine paintbrush, apply
the gesso to selected areas of the
letter, just within the outline.

4 Carefully remove any gesso from unwanted areas using an excise knife with a fine-pointed blade. Smooth the surface of the gesso with a sharp, curved blade or ultra-fine sandpaper. The more even the surface, the better the gilding will be. While doing this, protect the rest of the lettering with a piece of paper.

5 Finish smoothing the gesso with an agate or hematite burnisher. The surface should be slightly rounded – not flat.

6 Just before applying the gold, breathe on the gesso through a paper tube. This will create enough moisture to encourage the gold to adhere.

Applying gold leaf

1 Gold leaf is available in two forms: sheets of transfer gold and sheets of loose-leaf double gold. Fairly humid conditions are best for applying both types so good results are usually achieved early in the morning.

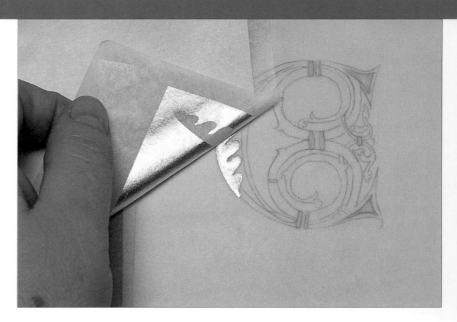

3 Peel back the sheet of transfer gold. The gold on the gesso will remain in place. If it does not adhere, breathe on the gesso again, and repeat the process.

2 If using transfer gold, place a piece over the gesso and press firmly with your finger. Speed is vital at this stage as you must apply the gold quickly after breathing on the gesso.

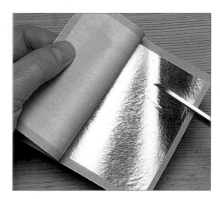

4 If using loose-leaf double gold, cut a piece slightly larger than the area of gesso. Leave the backing paper in place.

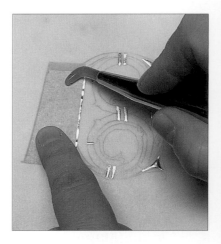

5 Position the loose-leaf double gold face down, and burnish firmly over the backing paper and gesso. A small dog-tooth burnisher is best for burnishing the slightly rounded gesso.

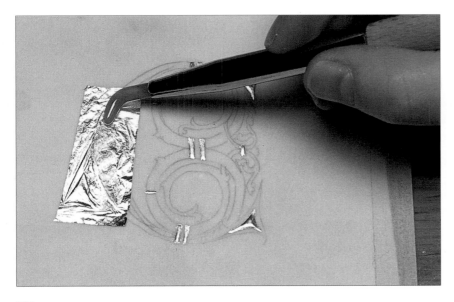

6 Peel away the backing paper and burnish the gold directly. Press it in all around the edges.

7 Use a soft brush to sweep away the loose gold that is not attached to the gesso.

8 Leave for 30 minutes, or longer depending upon atmospheric conditions. Gently burnish the gesso once again to achieve a high, mirror-like shine.

9 To complete the letter, fill the ungilded areas with gouache, using the pencil lines as a guide.

MATERIALS

Paper or vellum
Masking tape
Transfer paper
Pencil
PVA glue
Distilled water
Small palette
Gouache
Fine paintbrush
Fine-bladed excise knife
Transfer gold
Burnisher
Gouache
Mapping pen

ALTHOUGH GESSO IS THE BEST MEDIUM FOR CREATING RAISED GOLD LETTERS, A MIXTURE OF PVA AND DISTILLED WATER can produce surprisingly effective results. It is applied and used in much the same way as gesso but does not require any prior preparation.

1 Attach the paper to a flat surface with masking tape. Put a piece of transfer paper on top, and position the outline of your chosen letter over it. Hold both in place with masking tape. Carefully trace around the edge of the letter with a pencil.

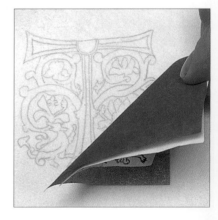

2 When the letter is complete, carefully peel back the transfer paper and original drawing to reveal the outline.

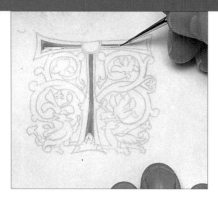

3 Mix a solution of 50 percent PVA and 50 percent distilled water. Add a little red gouache if the solution is being used on a white background. Apply the mixture to selected areas of the letter with a fine paintbrush. Leave to dry overnight in a dust-free environment and then remove any unwanted solution using a fine-pointed blade.

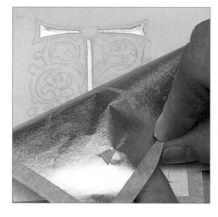

5 Peel back the sheet of transfer gold. If the gold does not adhere properly, repeat step 4.

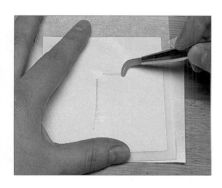

4 Breathe on the dried gum through a paper tube to make it moist, and then place a piece of transfer gold over the letter immediately, pressing it down firmly with your finger. Rub over the backing paper and gum with a burnisher.

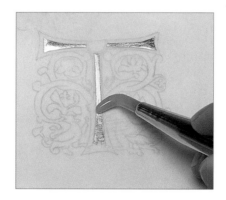

6 Leave for approximately 30 minutes. Gently burnish the transfer gold with a small dog-tooth burnisher.

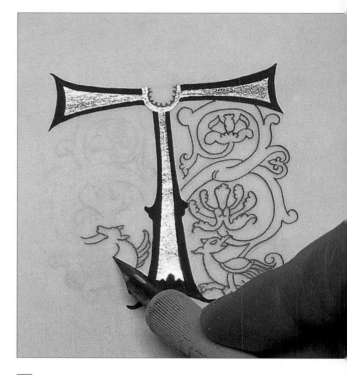

7 Apply colorful decoration in gouache with a fine paintbrush or mapping pen. The pen is especially good for intricate motifs with delicate lines.

Sculpting gold

A burnisher is used to model the gold loop in the middle of the letter. The central decoration is repeated in miniature on the outside.

Adding sparkle

Gum-based gilding can be given extra sparkle by making regular indentations in the finished gold with a clean, blunt point.

Linking device

A difficult letter to ornament, here the solution is to decorate both sides and link them across the middle.

Color foils

Black acts as a strong foil to the gilding. The red ornamentation is linked across the central bar to break up the gold further.

Clean edges

The main body of the letter is painted in a strong color around the gilding. This ensures clean edges to the gold.

Gold highlights

Only three strokes of the letter are gilded, leaving the remainder painted in gouache with more subtle white highlights.

GALLERY

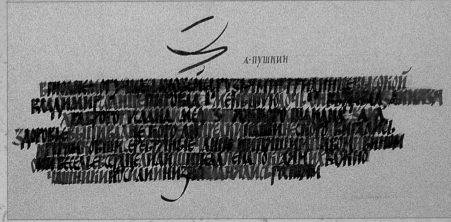

HAT FOLLOWS IS AN EXCITING COLLECTION OF COLORFUL WORKS, EXECUTED BY SKILLED CALLIGRAPHERS WITH A FLAIR FOR THE USE OF COLOR AND artistic interpretation. Notice what colors have been used, how they have been combined, what techniques have been employed. You will surely be inspired by this wealth of colorful creativity!

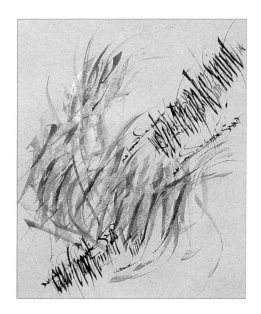

Jonathan Bulfin
PEARL FISHERS
Overlays of pearlescent inks on handmade paper shimmer in this design, which was inspired by the iridescence of a coral reef.

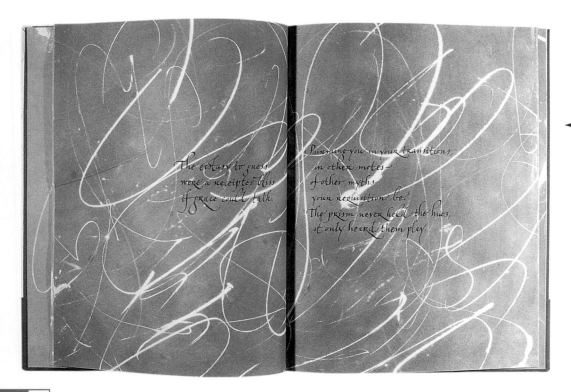

Rose Folsom
7 POEMS BY EMILY DICKINSON
Dilute bleach scrawled across the dyed pages gives a "neon" glow to reflect the bright nature of the poems, which are written in a handwriting script.

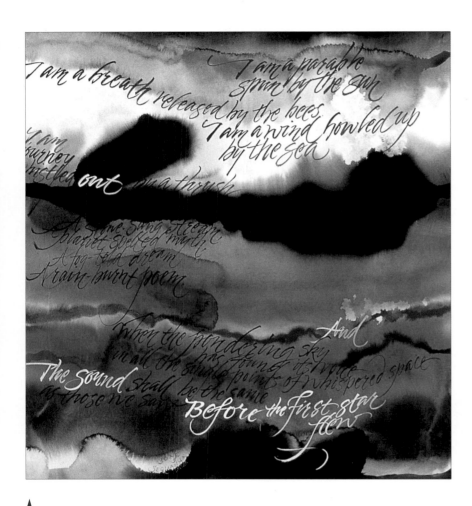

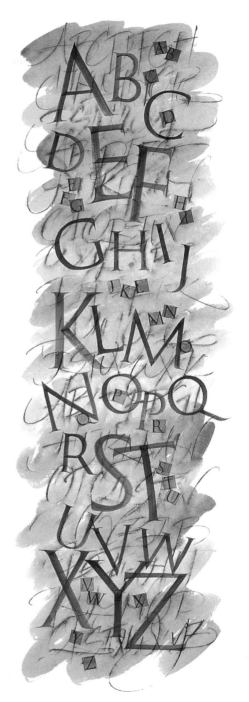

▶ **Jenny Hunter Groat**

PARABLE

*Exciting mood pictures
are created by wet-on-wet
watercolors, inks and
gouache laid on rag paper.
The fluid script is written
with a pointed brush.*

Mary Noble ▶

*CELEBRATING
CAPITALS*

*Edged brush capitals are
written on a watercolor
wash and ruling pen
background, with smaller
pen-made capitals in
painted squares.*

Rosie Kelly

THE STONE OF HEAVEN

The white text appears to float in front of the exciting and colorful "glittering hues" of the background, which was created with starch paste and pigment, gouache, watercolor, color pencil, pointed brush, metal nib, gold leaf and metallic ink.

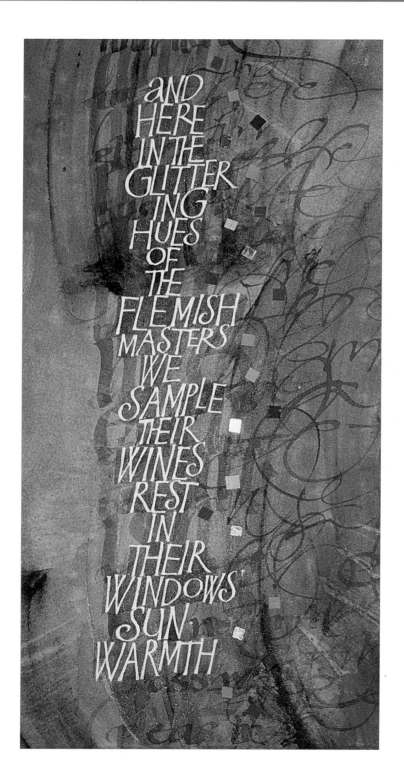

Paul Shaw

ALPHABET

This silkscreen printed promotional alphabet design was written with an automatic pen using subtle variations in the color tone.

Linda Sealy

PRAYER WHEEL

*Peace and unity,
symbolized in the
neverending circle, are
given colorful changes in
the chunky central letters
and the accompanying
repeat images.*

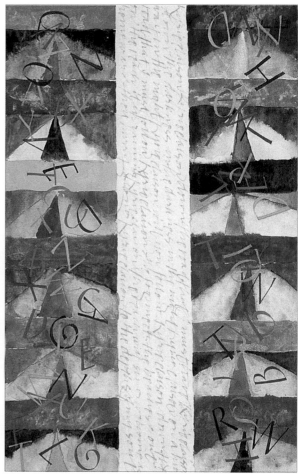

Nancy Leavitt

CROSSROADS

*Strong, bright colors in
sensitive combinations
attract the eye to this
page, and invite the reader
to search out the text.*

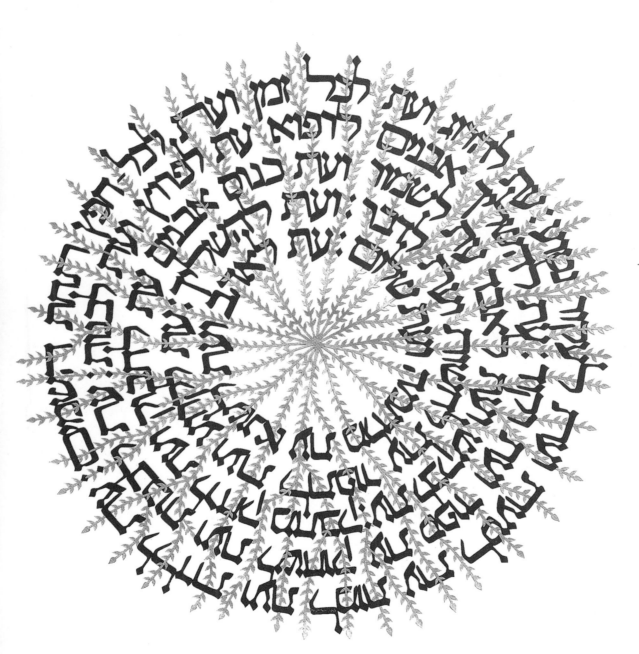

Luba Bar-Menachem

TO EVERYTHING THERE IS A SEASON Text cut from one piece of black paper is ornamented in gold paint and mounted between two sheets of glass. The text speaks of life in terms of a circle and the design uses leaves to represent growth and optimism.

Jenny Hunter Groat

WAKE-UP CALL
Dynamic brushstrokes of
ink make this a powerful,
carefully planned backdrop
for the flowing calligraphy
which is written using a
pointed brush.

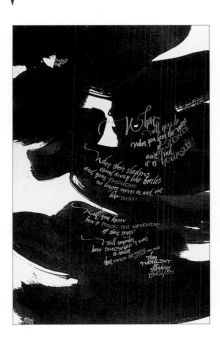

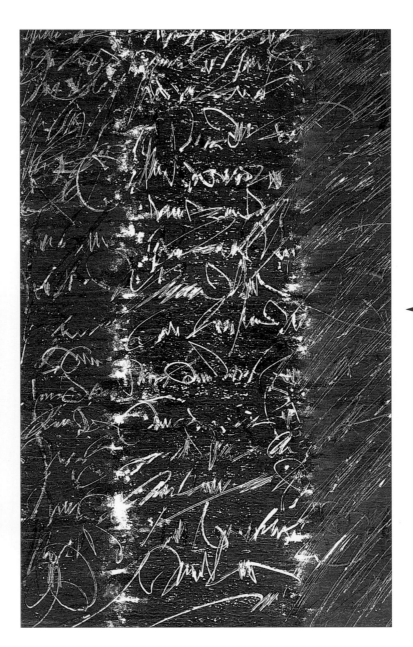

Henny van Renselaar

SCRIPTURE
This detail from a piece of
free calligraphy is written
in wax pencil and then
washed with color, giving
interesting textural effects
and drawing attention to
the movement and
structure of the writing.

Vivien Lunniss

"B"

This magnificent collection of techniques illustrates printing inks on vanishing fabric, gouache on watercolor paper, resist, gold leaf on a gum base and acrylic ink on calico.

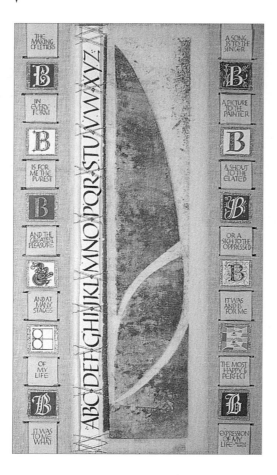

Rose Folsom

ST. LUKE'S PASSION

The calligraphy forms a plane of texture against strong areas of background color in this striking detail.

Shen Qiang

HIBI-KORE-KOUJITU
(Every day is a wonderful day)
Breaking new ground in
Japanese calligraphy, here
the lettering has become
abstract art in a graphic
display of line and color.

Rose Folsom

*STUDY IN PURPLE
AND GOLD*
Two contrasting scripts
against a background of
pastepaper (paste and
color spread on the paper
with various tools) creates
a harmonious and
mysterious mood.

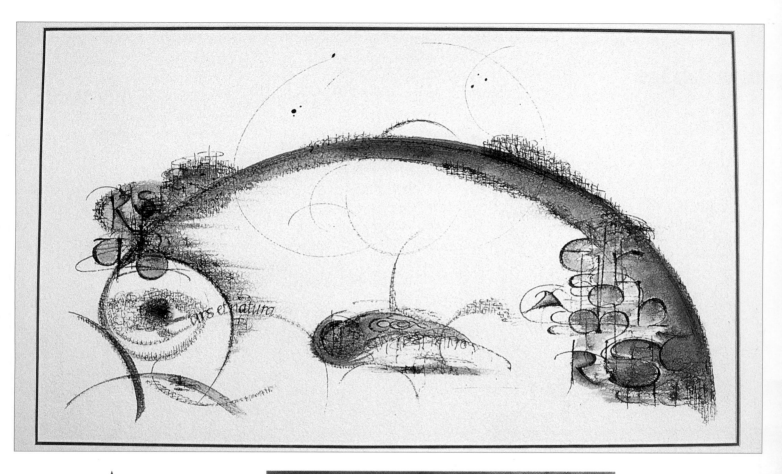

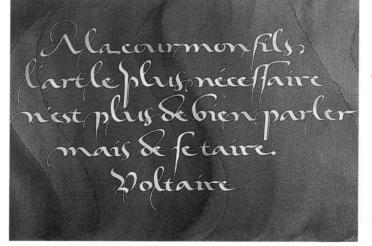

Godelief Tielens

ARS ET NATURA
This striking design of
curves is echoed in the
rounded script. Tight areas
of text contrast with the
wide open spaces.

Lieve Cornil

A LA COUR MON FILS
The swirling wisps in
the dark background are
echoed in the flourishes
of the white script. Note
how the white seems to
bring the words forward.

Valerie Weilmuenster

JEWISH PRAYER

This unusual book format, each page staggered in the binding to allow a part of each to be always visible, emphasizes the enjoyment the artist had in decorating the paper with starch paste, gouache and acrylic medium.

Janet Mehigan

KINGFISHER

An exciting background has been created with controlled watercolor washes and extra texture achieved by the use of salt and clingfilm. The design evokes the feeling of a kingfisher skimming for an instant on the water.

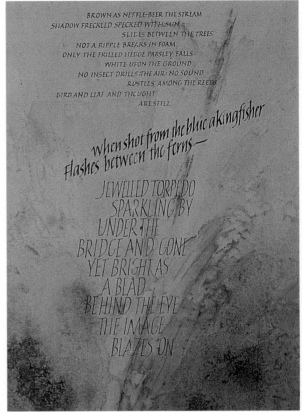

BROWN AS NETTLE-BEER THE STREAM
SHADOW FRECKLED SPECKED WITH SUN
SLIDES BETWEEN THE TREES
NOT A RIPPLE BREAKS IN FOAM
ONLY THE FRILLED HEDGE PARSLEY FALLS
WHITE UPON THE GROUND
NO INSECT DRILLS THE AIR: NO SOUND
RUSTLES AMONG THE REEDS
BIRD AND LEAF AND THOUGHT
ARE STILL

when shot from the blue a kingfisher
Flashes between the ferns—

JEWELLED TORPEDO
SPARKLING BY
UNDER THE
BRIDGE AND GONE
YET BRIGHT AS
A BEAD
BEHIND THE EYE
THE IMAGE
BLAZES ON

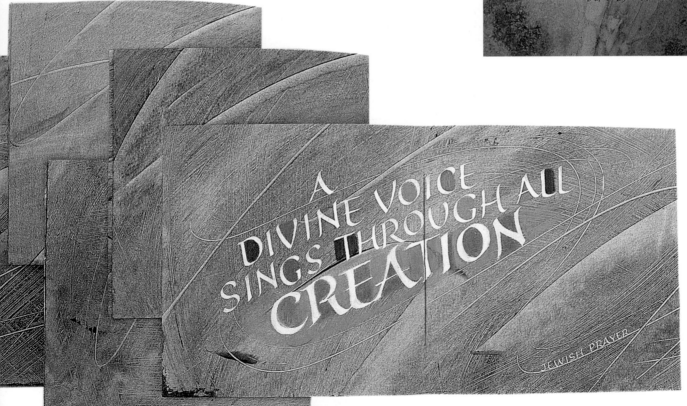

A DIVINE VOICE SINGS THROUGH ALL CREATION

JEWISH PRAYER

Rose Folsom

COLOR STUDY I

A subtle range of colors
laid over masked-out
strips create visual
interest, with free flowing
script forms adding
texture to the piece.

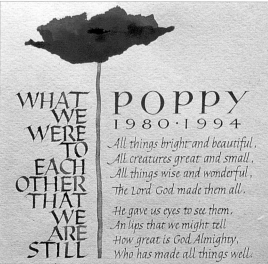

John Smith

POPPY

A delicate watercolor
rendering of the single
poppy uses the stem as a
divider for the carefully
written text.

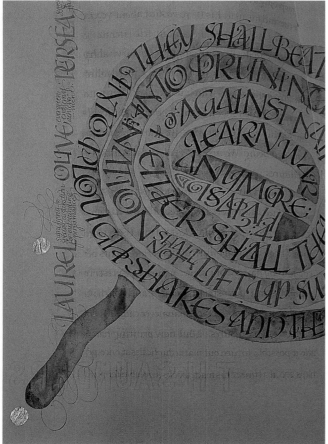

Suzanne Moore

*SPEAK TO THE
EARTH: MAZE*
*This detail is from a book
made using dyed and
painted papers. The
gouache lettering is written
in oval shape across the
double page spread and
decorated with pastels,
vinyl paint, gouache and
gum-based gilding.*

Barbara Breune

*EVE: THE SERPENT'S
GIFT*
*Leaf forms are printed
onto various papers which
are then folded and cut to
create a sculptural folding
book. The text is written
in the forms remaining.*

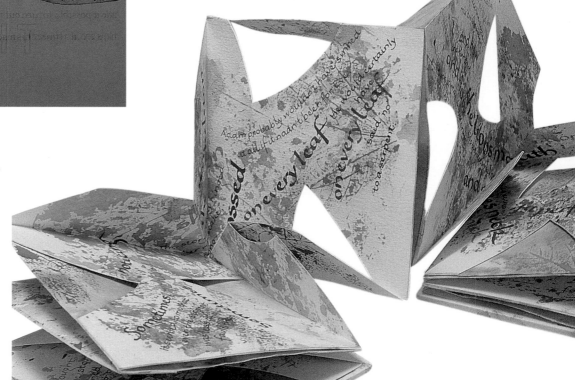

INDEX

All techniques are illustrated. Page numbers in *italics* refer to illustrations in Gallery section.

CREDITS

Acknowledgments

Quarto would also like to acknowledge and thank all the calligraphers who have kindly allowed us to reproduce examples of their work in this book.

Four calligraphers contributed to the step-by-step demonstrations. While the techniques shown are often more than one person's work, the color variations that follow each technique can be identified as follows:

Janet Mehigan pages 54, 59, 63, 70, 81, 88, 93, 111, 141

Annie Moring pages 39, 47, 119, 125 *(A)*, 136, 145, 152, 160

Mary Noble pages 31, 35, 85, 97, 103, 125 *(B, C)*, 133

Adrian Waddington pages 43, 67, 75, 107, 115, 129

Additional credits: page 1 *Celebrating Capitals* by Mary Noble; page 2 *Siesta* by Janet Mehigan; page 24 (left) photo by Dwight Kuhn; page 160 (above) *Color Study II* by

Rose Folsom; page 160 (below left) *Mysterious* by Godelief Tielens; page 160 (below right) from Pushkin's *Ruslan and Ludmila*, by Leonid Pronenko; page 169 (right) Shen Qiang appears courtesy of Asahi Art Communication, Tokyo, Japan; page 171 *Kingfisher* by Janet Mehigan is based on a poem by Phoebe Hesketh, taken from *Netting the Sun*, published by Enitharmon Press, 1989.

All other photographs are the copyright of Quarto.

Suggested reading

The following books are recommended for more detail on color theory, or for sound calligraphic exemplars and further ideas for creativity.

Blue and yellow don't make green, Michael Wilcox
The elements of color, Johannes Itten
Advanced calligraphy techniques, Diana Hoare (see section by Bob Kilvert on watercolor washes)
Calligraphy made easy, Gaynor Goffe
Calligraphy, art and color, Peter Halliday

Letter Arts Review, quarterly magazine by subscription, 1624 24th Avenue SW Norman, OK 73072, USA
Lettering Arts, Joanne Fink
The calligrapher's project book, Suzanne Haynes
Step-by-step calligraphy, Susan Hufton
Colors and what they can do, Louis Cheskin

Calligraphy societies

Society of Scribes Ltd
PO Box 933
New York
NY 10150
USA

Society of Scribes and Illuminators
6 Queen Square
London WC1N 3AR
UK

Calligraphy and Lettering Arts Society
54 Boileau Road
London SW13 9BL
UK

Australian Society of Calligraphers
PO Box 184
NSW 2114
Australia